IMAGES
of America

DALTON

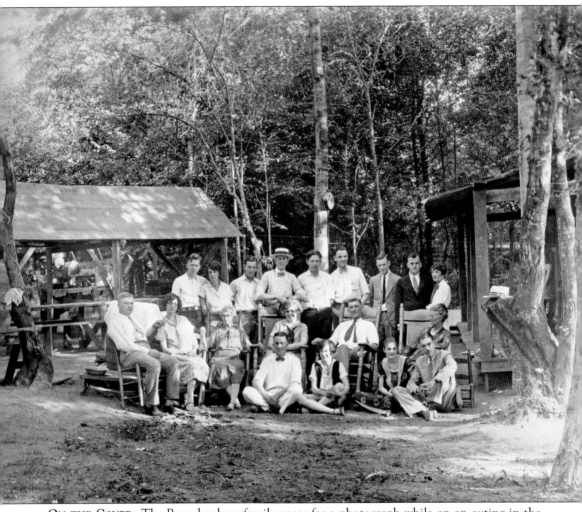

On the Cover: The Rauschenberg family poses for a photograph while on an outing in the 1930s. The family lived in the Trammell house, which was moved in 1927 from its location on Thornton Avenue to its present location in the McCarty subdivision. The Rauschenbergs completely renovated the old house, using a decorator from Atlanta, and landscaped the grounds using plants from Lenna Judd's gardens. They had the first private in-ground swimming pool in Dalton. G. H. Rauschenberg was part owner of the Kenner-Rauschenberg bedspread plant. (Courtesy of Georgia Archives, Vanishing Georgia Collection, Image No. WTF312.)

IMAGES
of America

DALTON

Thomas Deaton, Myra Owens, Brenda
Ownbey, Tammy Poplin, Vanessa Rinkel,
and the C³ Center Students
Foreword by Deborah Norville

ARCADIA
PUBLISHING

ISBN 978-0-7385-6708-2

Published by Arcadia Publishing
Charleston SC, Chicago IL, Portsmouth NH, San Francisco CA

Printed in the United States of America

Library of Congress Catalog Card Number: 2008932134

For all general information contact Arcadia Publishing at:
Telephone 843-853-2070
Fax 843-853-0044
E-mail sales@arcadiapublishing.com
For customer service and orders:
Toll-Free 1-888-313-2665

Visit us on the Internet at www.arcadiapublishing.com

*This book is dedicated to the loving memory of Peter Bouldin Andersen,
a rising fourth-grade student at the C^3 Center.
Born May 27, 1999, and died June 3, 2008.*

CONTENTS

FOREWORD

"I look to the hills, from whence cometh my strength." Those words from the Bible particularly resonate for most anyone who hails from northwest Georgia, particularly Dalton. Nestled between two stately mountain ridges, growing up I felt a comfort and calm every time I glanced at those hills. The beauty of Dalton and Whitfield County is unmistakable.

Less immediately apparent is the quality of its people.

I was recently asked to think about what it was like growing up in Dalton, Georgia, and Whitfield County. The image of a tufted chenille bedspread immediately appeared in my mind's eye. It was not because tufting, a stitch perfected by Catherine Whitener, put Dalton on the map—though certainly my family and just about every other family I knew was somehow connected to the tufted textile industry. There were even a few mom-and-pop operations selling bedspreads from their front yards back then. But that was not why I thought "bedspread."

The chenille spread in my mind was filled with exquisite tufts, each of which represented a character-building experience in my mind: the Girl Scout leader who taught us bird signs, the teacher who explained chemistry, the coach who drilled us so we would win the big game, the parents who corrected us, and the Sunday school teacher who made us memorize Bible verses all made an impact. Each tuft represents a person who inspired, a lesson learned, a hug received or dispensed. Dalton, Georgia, was a town that cared about its young people, and everyone mentored each other's child to insure they "turned out right."

The African Zulu have an expression: "It takes a village to raise a child." I know the village of Dalton, Georgia, was important in raising this daughter of the South.

"My word is my bond." "God has a plan." "The sky's the limit." "No one ever died of hard work." These were expressions I heard daily as a little girl. Values were stressed, but more important, values were demonstrated in every aspect of daily life.

Two hundred years ago, when the Cherokees first moved into the North Georgia mountains, they called the area the "Enchanted Land." Looking at the spectacular success of the industry that was spawned here and the people who were a part of it, it is hard to argue against the Cherokees' assessment. I am proud to call Dalton, Georgia, home, and I am delighted this book has been written to introduce you to our "enchanted land."

—Deborah Norville
2008

INTRODUCTION

When Spanish explorer Hernando De Soto reached north Georgia in July 1540, he found hardwood forests and small clearings inhabited by fox squirrels, American elk, bobcats, otters, and even black bears. Just to the south of present-day Dalton, the expedition visited the township of Coosa, which was the largest Mississippian village in southern Appalachia. Fields of maize and beans stretched for many miles to sustain the large population. Unfortunately, the Europeans also brought disease, which killed more than 90 percent of the eastern Native American tribes. More than a century later, in the late 1600s, when the Cherokees began to migrate into the area, they found fields and villages nearly empty. The land was so fertile and forested that they called it "the Enchanted Land." Initially, the Cherokees benefited from the same flora and fauna their predecessors had, with corn as the primary staple. The mountainous terrain protected them from incursions until white traders and trappers seeking hides and furs pressed into the ridge and valley region. Slowly, this caused the Cherokees to adapt such skills as the herding of cattle and pigs to supplement their maize crop. There was a good deal of sharing of the knowledge of the woodlands with the whites, and generally they lived in peace. Chief Young Bird had his home at a beautiful place now known as Hamilton Spring, and he raced his fine horses down his racetrack where Thornton Avenue is now located. The Lower Cherokees had a ball ground where the First Presbyterian Church of Dalton once stood. However, the white man's relentless desire for more land and the discovery of gold in northwest Georgia insured that all the treaty promises to the Cherokees would be broken. Against the determined wishes of the Cherokee chiefs at Red Clay, the federal and state governments forced them from their homes. Thousands died in the infamous Trail of Tears.

The year 1837 saw the beginning of a small village called Cross Plains where present-day Dalton is located. In 1843, the state legislature commissioned a state railroad to be built to connect the Central of Georgia Railroad and the Georgia Railroad with Chattanooga and points west. From Terminus, later called Atlanta, the Western and Atlantic Railroad (W&A) was constructed northwest through the vacated Cherokee lands. A syndicate led by Capt. Edward White of Massachusetts envisioned the possibilities on the rail line, bought the land, and laid out the town of Dalton, which replaced Cross Plains, with land parcels set aside for parks, schools, churches, and other public buildings. The principal streets were a mile long and were named for prominent citizens. The city was named in honor of Captain White's mother, whose maiden name was Mary Dalton. Soon the East Tennessee, Virginia, and Georgia Railroad from Bristol, Virginia, linked with the W&A, making the surging town a large transfer center. Hogs and cattle were brought from east Tennessee, wheat filled the terminals awaiting shipment, cotton came from the surrounding fields, and wagon trains of copper found their way from the mines in Ducktown, Tennessee. Numerous springs in the area attracted many who were seeking rest, recreation, and medicinal relief. Four hotels faced the train tracks, and business grew.

Then, in 1861, the South seceded from the Union, and Dalton's young men marched off to war. The great locomotive chase of the Confederate *Texas* after the Union-seized *General* brought

a brief but frenzied event to Dalton in 1862. Unfortunately, in 1863, the Confederate victory at Chickamauga, the siege of Chattanooga, and then the defeat by the Federal forces in the Battle above the Clouds brought the Confederate retreat to the Dalton area. Dalton had been caring for the wounded from these clashes, but now the town found itself at the center of Gen. William T. Sherman's large force. The confederate troops were under newly appointed general Joseph E. Johnston. Mill Creek flooded Dug Gap, and the ridges were fortified. After a bleak winter face-off, the Union troops outflanked the Confederates, the march to Atlanta continued, and Dalton became the temporary headquarters for Union forces. Later, in 1864, the city would see brief action, but it had already suffered badly from the war.

One of the lessons taught to the South by the war was the need to move away from a totally agrarian economy and develop manufacturing. In 1884, local entrepreneurs established the Crown Cotton Mill to process local cotton with the help of cheap local labor. The mill struggled at first but grew rapidly between the mid-1890s and the end of World War I. The payroll expanded to nearly 1,000 workers, and consequently, the mill village expanded to accommodate hundreds of families. A complete culture developed around their work site, with mill-sponsored athletic teams and even a company band. A second plant, the Boyleston Mill, was added, and then the American Thread Mill was built south of town.

Meanwhile, a new source of income to Dalton had begun to emerge. In 1895, fifteen-year-old Catherine Evans had revived a Colonial practice by hand-tufting a bedspread, and those who saw it began requesting their own. With the growth of demand, family and neighbors were recruited to satisfy a rapidly expanding demand for chenille bedspreads, then toilet covers, robes, bath mats, and throw rugs. Haulers carried the tufting materials into the surrounding countryside, where housewives tufted for extra money and spread houses in Dalton processed the finished goods for shipment. The lure of money and the adaptation of sewing machines to multiple productions drew men into the business, and the area's economy survived the Great Depression. After World War II temporarily sidetracked the industry, the development of yardage machines, which could make tighter rows and wider widths, refocused the industry toward carpet and rugs. Gene Barwick was probably the first of many who saw the tremendous possibilities that tufted carpet offered. Bud Seretean, Jack Bandy, and Guy Henley of Coronet, Harry Saul of Queen, and I. V. Chandler of Patcraft were among the early tufted-carpet leaders. Quickly, every available space was consumed with spread laundries, dye houses, sample makers, and tufting machines. Supply could not keep up with demand, and constant technical advances pushed the industry forward. Former dry goods store owners, school teachers, mechanics, and salesmen became overnight millionaires. At one point, Dalton had more millionaires per capita than any other place in America. With the direction of Bob Shaw, Carl Bouchaert, Jim Jolly, and others, the industry has matured, and Dalton has continued to prosper with their economic help, as well as the industry's commitment to Dalton, whether in churches, community arts, or medical and recreation needs.

Since the 1960s, the town has developed an international complexion. In the 1980s, the demand for additional laborers for the expanding industries drew in small numbers of Hispanics, who came first to work in the chicken processing plants. When it was realized that even though their language skills were weak, their work ethic was incredible, the mills began to employ them. In the past two decades, the town has been solidified into a truly international city with a minimum of social problems. Dalton is a maturing, growing, and progressive city with a wide-open future.

One

EARLY DALTON

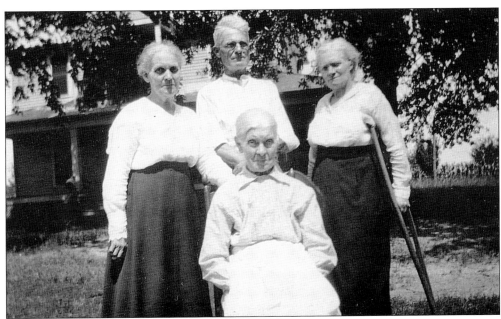

The Malcombs of Social Circle, Georgia, won land in the 1832 land lottery. The children could have the land if they lived on it. One child took the offer, Rebecca Malcomb, who married John Stark. They lived at Stark Springs on South 41 Highway. Pictured in 1917 in front of the Stark House, which is still standing, is Rebecca Malcomb Stark (sitting) and (from left to right, standing) Lizzie Mora Stark Ford, Buell Stark, and Nannie Stark Hyer. (Courtesy of Kim Purvis Crane.)

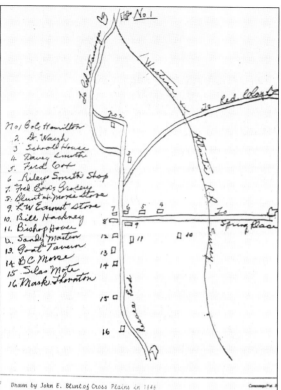

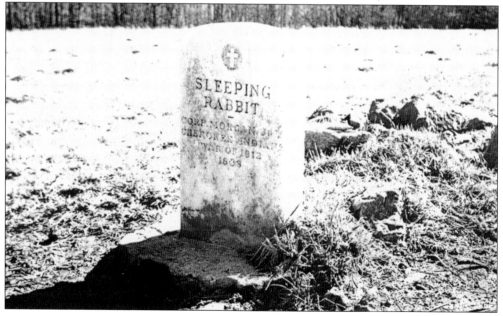

This map of Dalton, then known as Cross Plains, was drawn in 1846 by John E. Blunt, a son of Ainsworth Emery Blunt. The map shows the first 16 structures in town. The village of Cross Plains was a 400-yard circle, with the crossroads of the trail to Spring Place (now Morris Street) and the trail to Ross's Landing (now Thornton Avenue) as its center. (Courtesy of *From Cabins to Capitals*, Dalton Public Schools Heritage Unit, 1990.)

Pictured below is the grave of Chief Sleeping Rabbit in Cohutta, Georgia. The inscription reads "Corp. Morgan Jr.; Cherokee Indian; War of 1812; 1838." Sleeping Rabbit was a full-blooded Cherokee who at the time of the 1831 survey had 45 acres. The surveyed land was divided into lots of 160 acres, which was dispersed by land lottery in 1832. (Courtesy of Don Davis.)

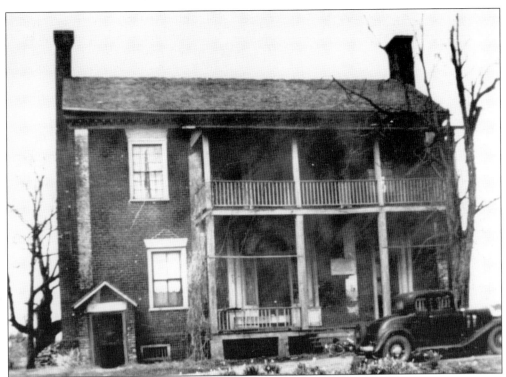

The Chief Vann House (above) was completed in Spring Place in 1804 by James Vann, a wealthy businessman and Cherokee leader. When Vann was murdered in 1809, the house passed to his 19-year-old son Joseph, who became even wealthier than his father, with 200 slaves and a 1,000-acre plantation. He lost possession of the house when the Cherokees were removed. The house has been restored and is open to the public as a Georgia Historic Site. (Courtesy of *Bicentennial Book*.)

George Whitefield, born December 16, 1714, in Gloucester, England, was an Anglican clergyman who worked with Charles and John Wesley and raised money for a Savannah, Georgia, orphanage. The Georgia Legislature honored his memory by naming Whitfield County after him in 1851. They purposely dropped the "e" so that it was pronounced the correct way. (Courtesy of Georgia Archives, Image No. SPC7/46.)

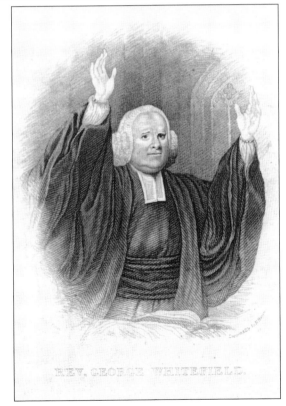

REV. GEORGE WHITEFIELD.

Hamilton House, the oldest home in Dalton, was built in 1840 by John Hamilton, who came to the area as a civil engineer for the W&A Railroad. During the Civil War, the house was used as a hospital for both sides and as the headquarters for the Kentucky Orphan Brigade. (Photograph by Forwell Studio, courtesy of Whitfield-Murray Historical Society.)

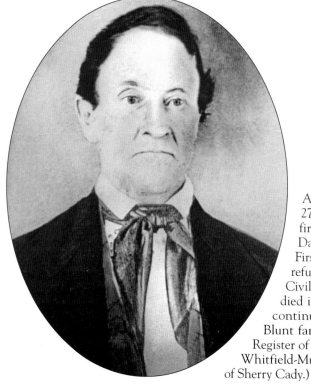

Ainsworth Emery Blunt, born February 27, 1800, in New Hampshire, was the first postmaster and the first mayor of Dalton. He was also a founder of the First Presbyterian Church. He lived as a refugee with his son in Illinois during the Civil War, returned to Dalton in 1865, and died in December of that year. Occupied continuously by three generations of the Blunt family, the house is on the National Register of Historic Places and is owned by the Whitfield-Murray Historical Society. (Courtesy of Sherry Cady.)

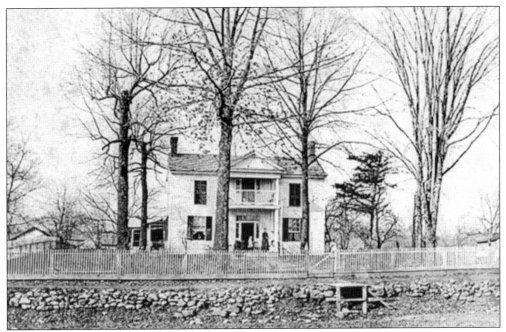

On the Blunt House front porch around 1868 are Lillie Blunt Kirby (center) and daughters Lucy (left) and Carolyn (right). The woman in the window at left is Lillie's mother, Elizabeth Ramsey Blunt. The black woman in the yard at right worked for the family. Ainsworth Blunt built what is now Dalton's second oldest home in 1848. The house was spared by the Union army and served as a Federal hospital from May to October 1864. (Courtesy of Whitfield-Murray Historical Society.)

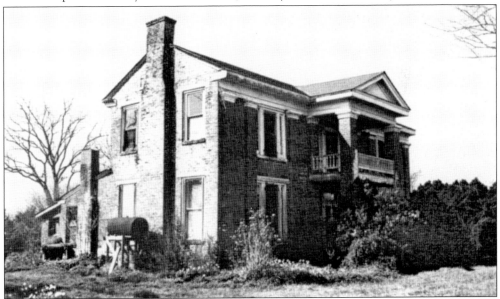

Walnut Grove, pictured here around 1976, was built by the Sutherland family about 1852. Eighteen-inch-thick walls were constructed with bricks made on the property. During the Civil War, Federal troops used the house to stable horses. Local history indicated that Gen. William T. Sherman's army wanted to burn the house but spared it when they found a U.S. flag painted on the roof. (Courtesy of *Bicentennial Book.*)

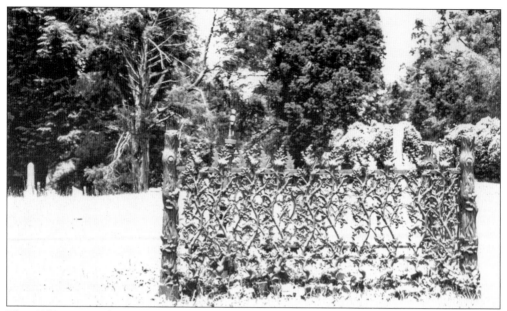

This 1858 grave within an intricate wrought iron fence in West Hill Cemetery is of little Emilie Peacock, aged 23 months, a daughter of Mr. and Mrs. C. M. Peacock. The family was in the wrought iron business and left Dalton shortly after her death. (Courtesy of Marcelle Coker White.)

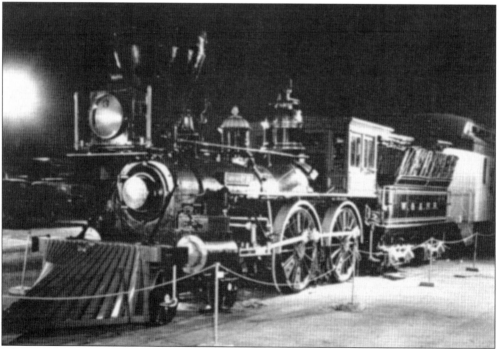

The *General* was the locomotive that Union spies stole from Kennesaw in April 1862, led by James Andrews. It ran out of steam two miles north of Ringgold Gap. The men ran away, but seven, including Andrews, were caught by Gen. Danville Ledbetter's men after the *Texas* stopped in Dalton to drop off a 16-year-old telegraph operator, who rushed into the depot to send a wire. (Courtesy of *Bicentennial Book*.)

This Confederate fort was built north of Dalton in 1862, near present-day West Yellow Knife. This type of fort, known as a block house, was constructed to protect railroad bridges. It was taken over by Union troops in 1865. Shortly after the war, it was dismantled to rebuild other structures damaged during the war. (Courtesy of Sherry Cady.)

Buzzards Roost is pictured in this George Bernard photograph. Gen. William T. Sherman inspected the field and called the bluffs of Rocky Face "the doors of death." This valley was his first challenge in the Atlanta campaign. The Battle of Rocky Face raged from May 8–10, 1864. In the end, Gen. Joseph E. Johnston withdrew his Confederate troops to Resaca. (Courtesy of *Views of Sherman's Campaign.*)

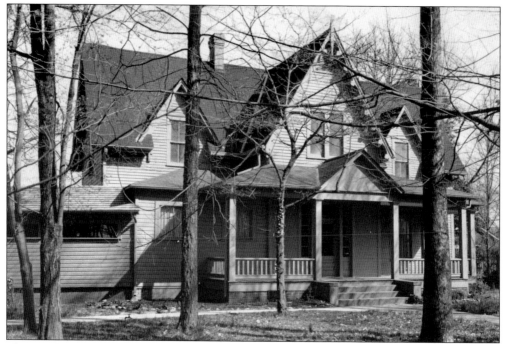

The Cook-Huff House, built in 1849, is located at 14 North Selvidge Street. Gen. Joseph E. Johnston occupied the house as his headquarters from December 1863 through March 1864. There is a nick in the banister said to be made by Johnston's sword. In the early 1900s, the house, then owned by W. C. Huff, was turned to face the street rather than the railroad. (Photograph by Forwell Studio, courtesy of Whitfield-Murray Historical Society.)

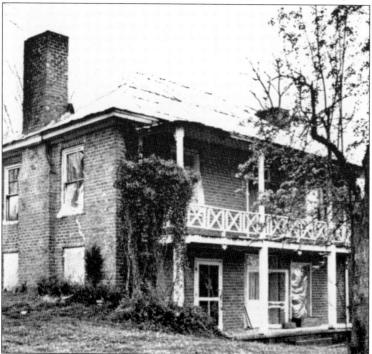

The Clisby Austin House, built in 1848, was used as a Civil War hospital where Confederate general John Hood was sent to recuperate, accompanied by his amputated leg, to be buried with him in case he died. He survived, and his leg is buried nearby in the family cemetery. The house was also a headquarters of Union general William T. Sherman. The house, a private residence, is located in Tunnel Hill. (Courtesy of *Bicentennial Book*.)

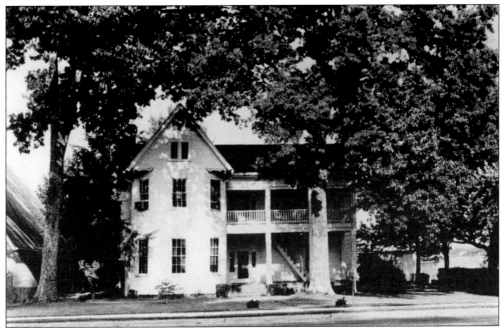

Pictured is the Duff Green House on Thornton Avenue, home of Gen. Duff Green, born in Kentucky on August 15, 1791. He was a newspaper editor and a member of Pres. Andrew Jackson's inner advisory circle, known as the "Kitchen Cabinet." In 1942, this house was purchased by the Catholic Church from the Carrie Green estate and was remodeled to hold mass. It was torn down when an addition was made to the church. (Courtesy of St. Joseph's Catholic Church and Wyatt Cushman.)

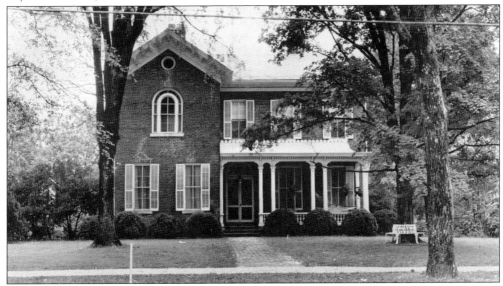

Built by Cicero Decatur McCutchen, the McCutchen Place on Thornton Avenue was the first house to be built in Dalton after the Civil War, in 1867. The bricks were hand molded on-site, and a German cabinetmaker hand-carved the intricate woodwork. The walls are 24 inches thick, and the ceilings are 12 feet high. Four generations lived in the home from 1867 until 1984. (Courtesy of Whitfield-Murray Historical Society.)

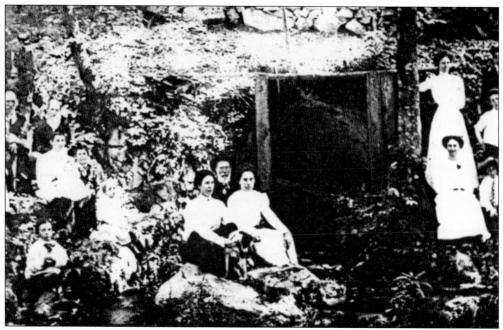

Northwest Georgia is home to abundant mineral springs, which were popular gathering places for families. Pictured here is Freeman Springs around 1880. (Courtesy of *Bicentennial Book*.)

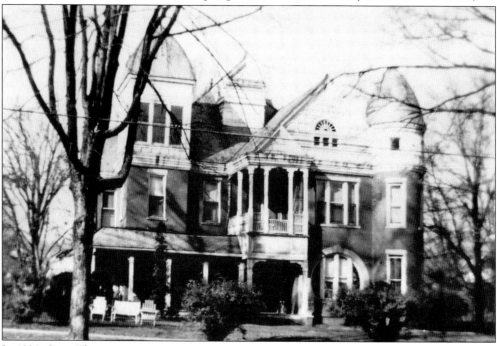

In 1890, Capt. Thomas Marvin Felker, a wealthy investor, began to build his palatial Queen Anne Revival–style home. Eventually, the family had 10 children. Over the years, four generations of Felkers lived in the home. A favorite among locals and visitors alike, the Felker house has undergone three major changes in the roof line, including the removal of spires and towers, but it still retains its majesty. (Courtesy of Whitfield-Murray Historical Society.)

Gertrude Manly Jones poses with her harp in 1890. She was the founder of the Lesche Women's Club, the oldest women's club in Georgia, which was founded in September 1890. The club was established because a group of young Dalton maidens felt "a burning desire to continue their studies" after graduating from the Dalton Female College. (Courtesy of Georgia Archives, Vanishing Georgia Collection, Image No. WTF187.)

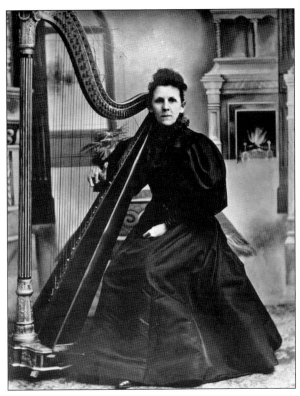

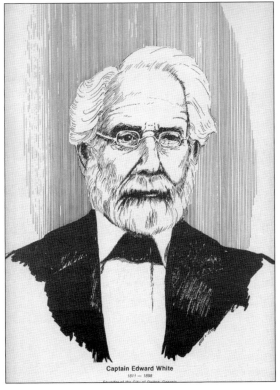

Captain Edward White
1811 — 1898

Edward White, pictured around 1895, was a commercial merchant on Wall Street who came to Cross Plains with his new wife, Mary Avaline Cunningham, to purchase property around the area where a railroad was to be built. He laid out the town and named the streets for local citizens. The place where he marked the center of Dalton is in the Depot Restaurant. He died on January 20, 1898. (Courtesy of Johnny Joyce.)

19

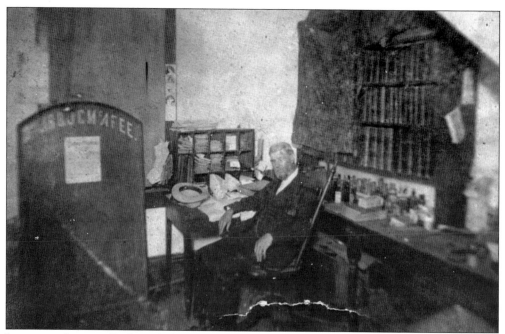

Longtime physician Dr. Jesse R. McAfee is shown in his office on King Street in 1898. He was a doctor in Dalton for 65 years. He served on the board of trustees of the Dalton Female College. During the Civil War, he served as a surgeon with the 36th (Broyles's) Regiment Georgia Volunteer Infantry. (Courtesy of Georgia Archives, Vanishing Georgia Collection, Image No. WTF213.)

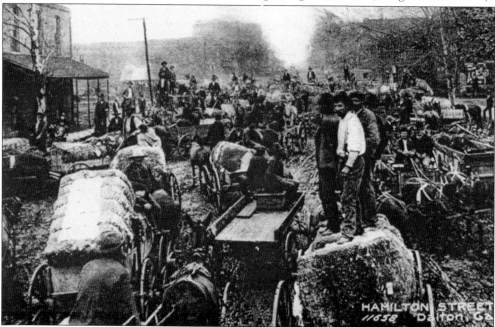

By 1900, most farming in northwest Georgia was small scale, with individual small farms or sharecroppers. Farmers brought their cotton in bales to this busy auction on Hamilton Street, as pictured here in 1900. George Horan is in the white shirt at right, front. (Courtesy of Jackson Poole.)

By 1890, cotton was the major crop in northwest Georgia. Pictured above are wagons bringing cotton to Vining Cotton Gin around 1900. (Courtesy of *Bicentennial Book*.)

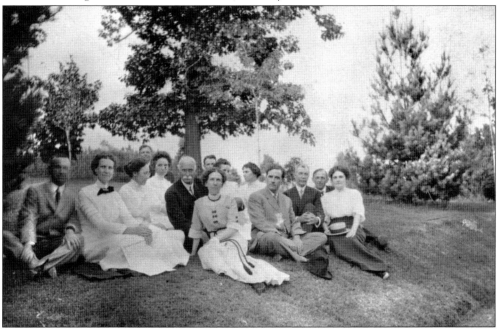

Friends gathered at Lenna Judd's home pose for this photograph in 1902. Pictured from left to right are Will Denton, a Mrs. Martin, Willie White, Will D. Wailes, William Nathaniel Harben, May Davis, Mrs. B. A. Tyler, Mrs. Robert Julian McCamy, Ed Davis, Billy Martin, Robert Loveman, Maybelle Harben, and two unidentified in back. (Courtesy of Georgia Archives, Vanishing Georgia Collection, Image No. WTF109.)

Will Harben, born on July 5, 1858, in Dalton, stands at the McCamy house on Spencer Street in 1903. Harben, a close friend of Robert Loveman, was a popular novelist. He wrote 30 novels and numerous short stories revolving around north Georgia's land and people. He died on August 7, 1919, in New York City and is buried in Dalton's West Hill Cemetery. (Courtesy of Georgia Archives, Vanishing Georgia Collection, Image No. WTF102.)

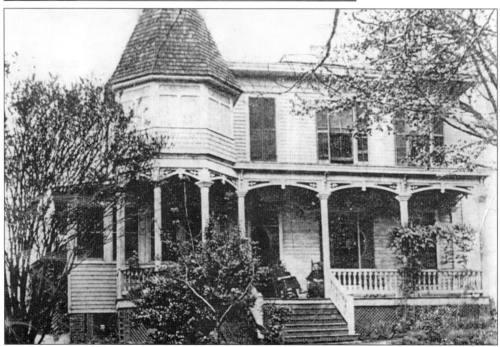

Robin's Nest, formerly located on the corner of Thornton Avenue and Waugh Street, was home to poet Robert Loveman, Dalton's most well-known poet. He wrote "The Rain Song" and the words for "Georgia," the state's official song from 1922 until 1979. Born in Cleveland, Ohio, on April 11, 1864, he moved with his family after the Civil War to Dalton, where they opened Loveman's Dry Goods Store. (Courtesy of Whitfield-Murray Historical Society.)

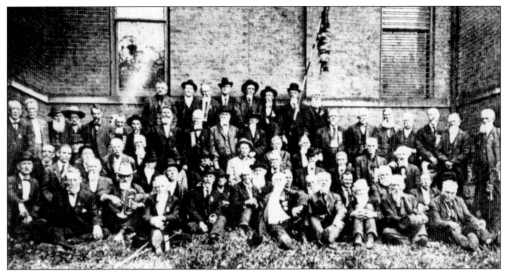

The members of the Joseph E. Johnston Camp No. 34 of the United Confederate Veterans pose for a picture on the side of the Whitfield County Courthouse in 1909. The camp was organized in 1891. Note the age of the veterans. (Courtesy of *Bicentennial Book.*)

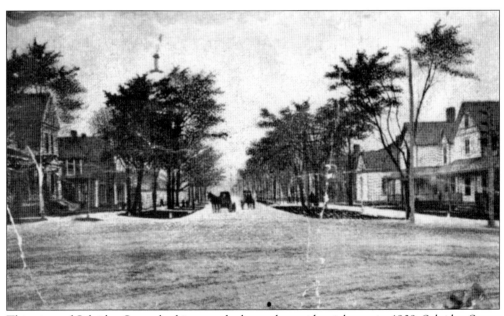

This view of Selvidge Street looking north shows the residential area in 1909. Selvidge Street was named after G. W. Selvidge, the first pastor of First Baptist Church. It was one of the first residential neighborhoods in Dalton. (Courtesy of Anthony and Evan Pope.)

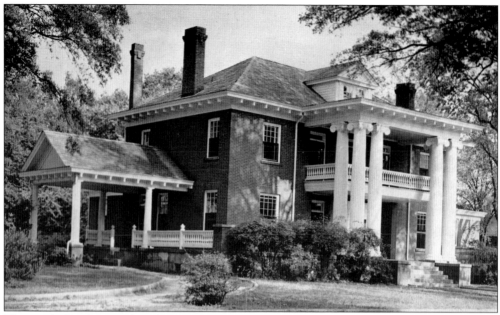

The stately Greek Revival–style Martin House was built in 1911 for Col. William Clinton Martin. Martin was an attorney, state senator, president of the First National Bank of Dalton, and chairman of the Whitfield County Board of Education for 30 years. Used as the Dalton Regional Library from 1948 until 1982, it has now been renovated as offices and is on the National Register of Historic Places. (Courtesy of Whitfield-Murray Historical Society.)

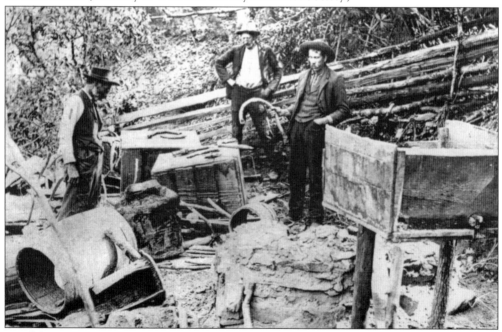

Local farmers sometimes supplemented their income by distilling corn liquor. While it was not illegal to produce liquor, it was illegal to avoid paying the federal liquor tax. These people were called "moonshiners" because they operated these illegal stills at night. Pictured is a still destroyed by revenuers, whose job it was to break up these stills. (Courtesy of Hal Millsaps.)

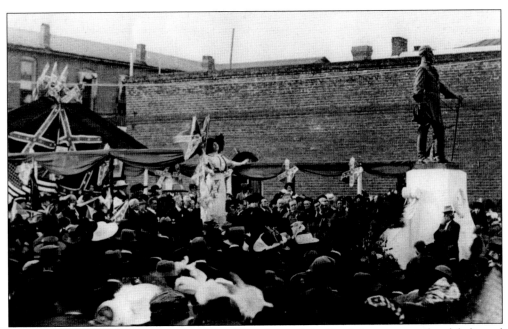

The Bryan M. Thomas chapter of the United Daughters of the Confederacy erected and dedicated this statue of Gen. Joseph E. Johnston in 1912 at the cost of $6,000. Johnston spent the winter of 1864 in Dalton, Georgia. Soon after assuming command, he telegraphed the war department at Richmond, Virginia, telling them that 13,000 of his men did not have shoes. Pictured singing is a Mrs. Gavitt. (Courtesy of Whitfield-Murray Historical Society.)

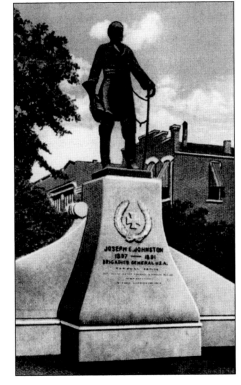

This c. 1940 postcard shows the only existing statue of Confederate general Joseph Eggleston Johnston, located at the corner of Hamilton and Crawford Streets. Johnston was the first graduate of West Point Military Academy to obtain the rank of general, and he was the highest ranking U.S. Army officer to leave his post in 1861 and join the Confederacy. (Courtesy of Georgia Archives, Vanishing Georgia Collection, Image No. WTF100.)

From left to right, Vera, Elise, and Sherman Nix stand at the spring at Crown Gardens in 1918. This spring provided the water for the city of Dalton from 1887 through the early 1920s. (Courtesy of Marcelle Coker White.)

William Ragsdale Cannon grew up on Selvidge Street. He was a United Methodist bishop, a scholar, and an educator. He served as the unofficial envoy to several countries for former U.S. president Jimmy Carter and was dean of Emory University's Candler School of Theology. At the age of eight or nine, he would gather children from the neighborhood and preach a sermon. Cannon Chapel at Emory is named in his honor. (Courtesy of Moore Methodist Museum.)

Pictured in this Finley Studio photograph is postman and former Baptist preacher James Thomas Wills. He and his wife, Mattie Belle Wood Wills, lived and raised eight children at the corner of Waugh Street and Glenwood Avenue. His difficult postal route covered the entire city of Dalton, and he often made his deliveries via bicycle. (Courtesy of Georgia Archives, Vanishing Georgia Collection, Image No. WTF097.)

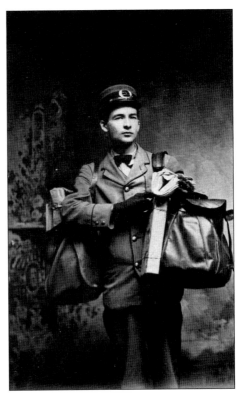

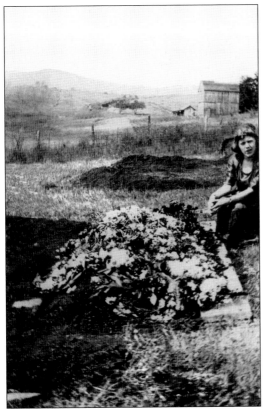

Pauline Rhudy, fiancée of Onie Nix, kneels at his grave in West Hill Cemetery in 1920. Nix was electrocuted at the Crown Cotton Mill when someone mistakenly turned a switch. Note the rural farmland in the background. (Courtesy of Marcelle Coker White.)

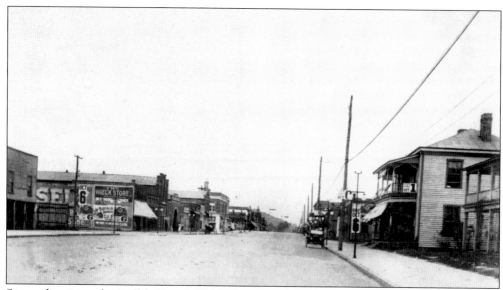

Signs advertising the Buffalo Ranch Wild West Show line the sides of Hamilton Street looking north in the 1920s. There is a mix of old and new, with unpaved streets and wagons, automobiles, and electricity wires. (Courtesy of Crown Garden and Archives.)

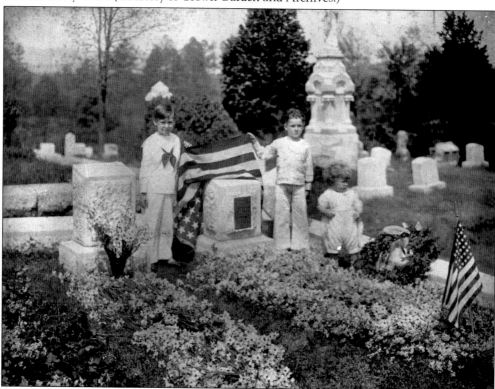

From left to right, Harry Lee Jarvis Jr., McChesney Hogshead Jr., and an unidentified child gathered around a plaque that marks the grave of Phoebe Bryan Kelley, located in West Hill Cemetery, on April 17, 1925. She was the daughter of a soldier who fought in the Revolutionary War. (Courtesy of Georgia Archives, Vanishing Georgia Collection, Image No. WTF285.)

These children are playing in 1928. Note the dolls, clothing, and hairstyles. The little blonde girl in front is Frances Thomas. The boy behind her is "Baby Brother" Williamson. Their two families were friends, since both sets of parents were telegraph operators. The other two children are unidentified. (Courtesy of Kim Purvis Crane.)

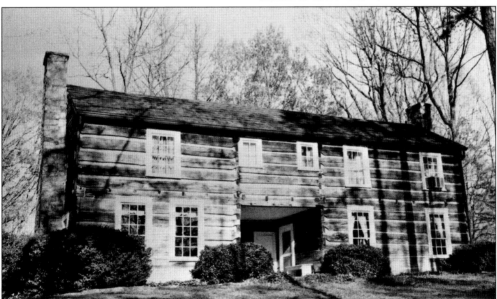

The Westcott double–log cabin with a dog trot was probably built in the 1830s and was originally located southeast of Red Clay. It was purchased by Lamar Westcott, who had it dismantled, the logs numbered, and then moved to Greenwood Drive in 1931. Behind the walls were a knife, a pipe, two coins, silver spoons, a testament, and a Whig Party campaign button. The home of Fred Westcott, brother of Lamar, it is now the home of Ann Davies. (Courtesy of Georgia Archives, Vanishing Georgia Collection, Image No. WTF161.)

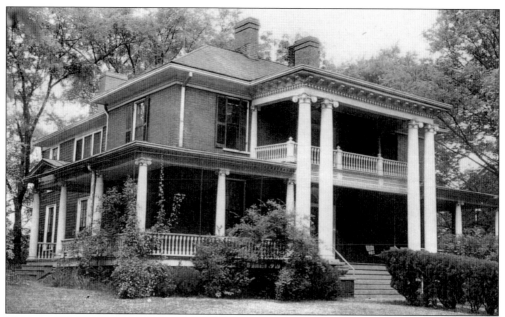

The gracious Manly home, pictured around 1957, was demolished to build First Baptist Church on Thornton Avenue. This pre–Civil War home was originally owned by the Swift family then by the Ben Prater family from the early 1880s. It was purchased by Frank Manly in 1908 and remodeled. In 1888, Manly established the Manly Jail Works, a company that built jail cells and rolling convict cages. (Courtesy of Judson Manly.)

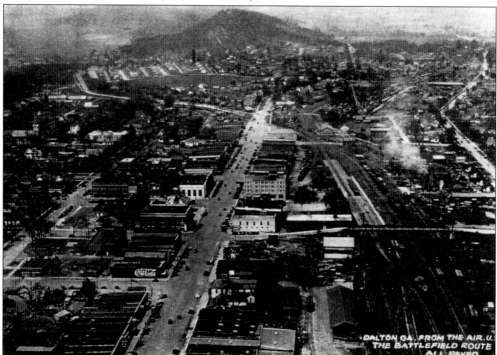

This 1932 aerial view of Dalton looking north shows the roads all paved. The main road at center left is Hamilton Street. (Courtesy of Sherry Cady.)

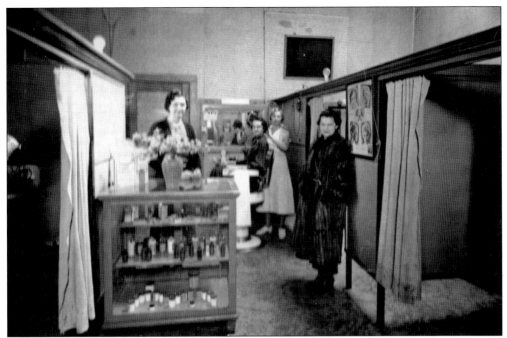

Dalton's first permanent was given at the Tip Top Beauty Shop on King Street in the 1930s. Pictured from left to right are Willie S. Ray, Virginia Ray Shope, Ruth Shope, and Edress Stacy Smith. (Courtesy of Taylor Boyett.)

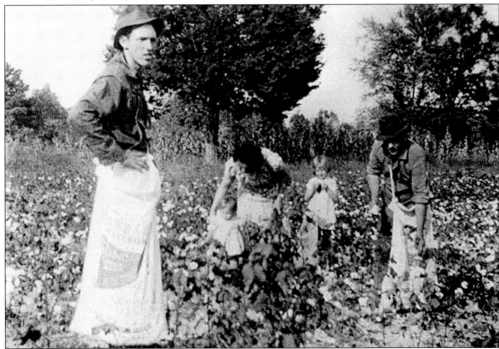

At cotton harvest time, the whole family helped, even the children. County schools would close so that everyone could help out. This photograph shows one such family around 1938. (Courtesy of Sherry Cady.)

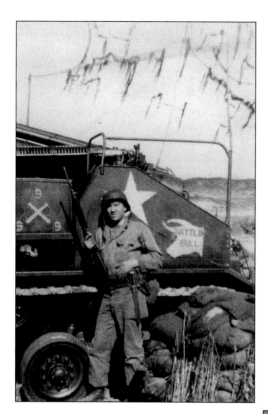

This picture of Robert Crider was taken somewhere in Europe during World War II. (Courtesy of Viola Quinn.)

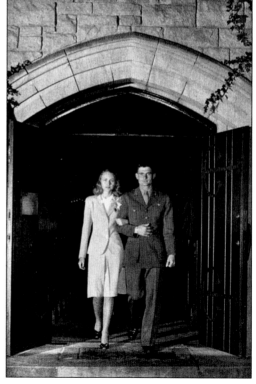

The date of March 21, 1945, was the wedding day for Frances Thomas and James Purvis at Wee Kirk o' the Heather Chapel, Forest Lawn, in Glendale, California. Jim was stationed at El Toro Marine Air Base in Santa Ana, California. Fran took the train from Dalton so the two could be married. They went to Big Bear, California, on their honeymoon. Jim, a marine fighter pilot, shipped out on April 1, 1945, to Okinawa by way of Pearl Harbor. (Courtesy of Kim Purvis Crane.)

Dicksie Bradley Bandy and Ray Vann, a descendant of Chief Vann, pose for this portrait by the Finley Studio around 1959 in the Bandy home in front of a portrait of Joseph Vann, which now hangs in the Vann House. Bandy led the effort to restore the Chief Vann House at Spring Place. For all her philanthropic accomplishments, she was named a Georgia Woman of Achievement. (Courtesy of Georgia Archives, Vanishing Georgia Collection, Image No. WTF318.)

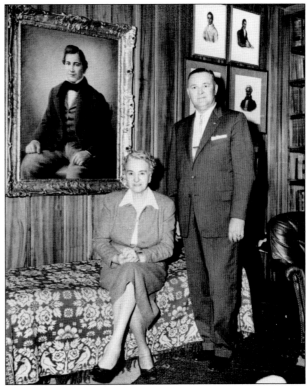

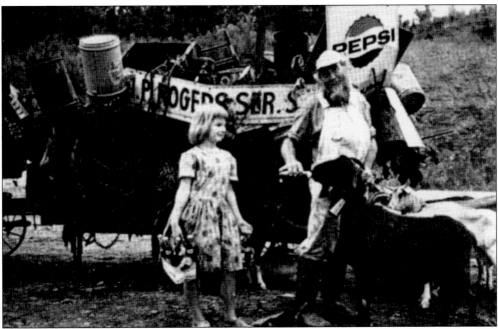

Chess McCartney, the legendary "Goat Man," walked through Dalton on his journey through rural America with a huge iron-wheeled wagon pulled by goats. The wagon was loaded with pots and pans, bails of hay, car tags, and a sign that said, "God Still Lives!" He traveled from Maine to Florida, covering almost 100,000 miles from 1930 to 1987. (Courtesy of *Bicentennial Book*.)

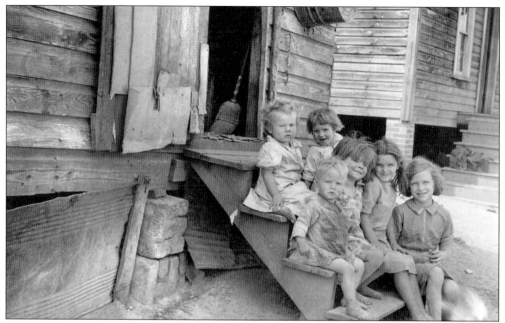

Children sit on the steps of a home in the Happy Top community in the 1930s. Happy Top was located in one of the most picturesque tree-lined parts of the city, where Dalton High School and surrounding neighborhoods are now. The homes built in the Happy Top community reflect the hard times and struggles many families faced during the difficult years after the crash of the stock market in 1929. (Courtesy of Jane Greer.)

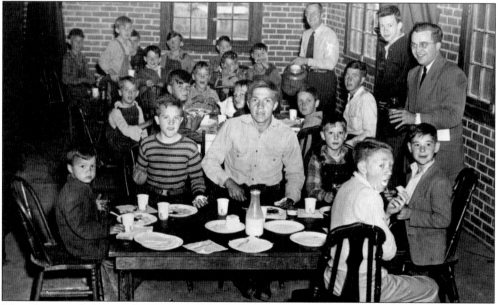

This photograph depicts the interior of the basement of the Friendship Chapel. The chapel was built in 1947 and was located on Wills Street. It was established as a mission of the Presbyterian Church and served people of all denominations. Rev. Clyde Plexico, a missionary, watches as a number of children from the Happy Top community eat lunch. (Courtesy of Georgia Archives, Vanishing Georgia Collection, Image No. WTF276.)

Two

LENNA JUDD

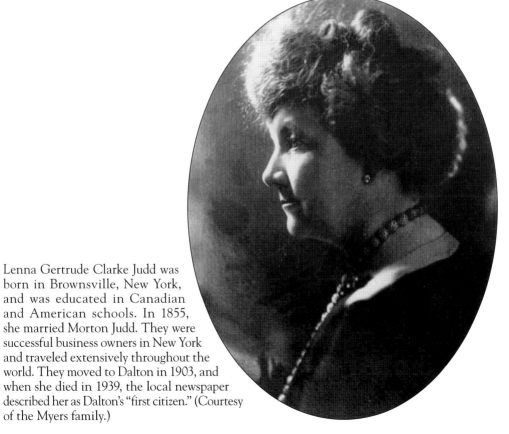

Lenna Gertrude Clarke Judd was born in Brownsville, New York, and was educated in Canadian and American schools. In 1855, she married Morton Judd. They were successful business owners in New York and traveled extensively throughout the world. They moved to Dalton in 1903, and when she died in 1939, the local newspaper described her as Dalton's "first citizen." (Courtesy of the Myers family.)

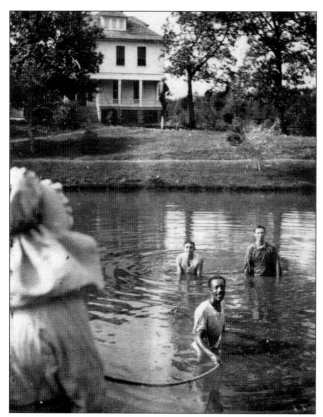

Lenna and Morton Judd were avid bicycle riders and would often pedal as much as 30 miles a day. Local folklore has it that they were pedaling to Florida and stopped in Dalton, where they were charmed by the people, climate, and countryside. They bought an old farm on the edge of town, away from the cold. Here workers are dredging the pond in front of the old farm house. (Courtesy of the Myers family.)

When Morton Judd's health deteriorated, the couple sold their business interest to Stanley Tool Works and moved permanently to the South. They had originally lived in the tasteful but modest home on the property, but after Morton passed away in 1919, Lenna Judd expanded the residence into the brick-and-stucco architectural masterpiece that was completed in 1921. (Courtesy of the Myers family.)

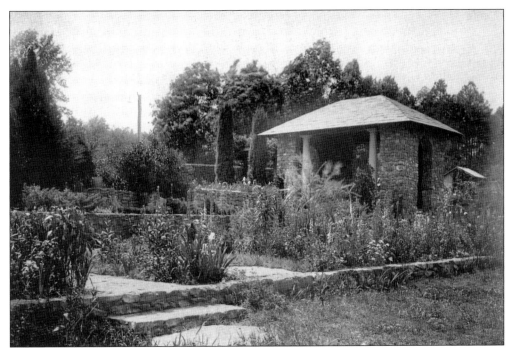

The Judds' home was and is to this day called Oneonta, which means "a place of rest." It was memorialized in a poem by that name by Ernest Neal, poet laureate of Georgia. The first stanza begins: "Oneonta! Can garden of Earth be sweeter,/ Thou gift of the sun and the rain?" (Courtesy of the Myers family.)

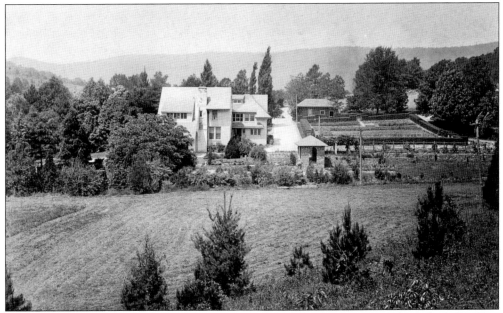

Lenna Judd was a self-taught landscape gardener who turned the swamps and red clay hills of her 150-acre Dalton estate into beautiful and elaborate gardens. She built an outdoor amphitheater and a teahouse made of stone. Additionally, she created terrace gardens, a large pond, and formal gardens that flanked the rear and sides of the great house. (Courtesy of the Myers family.)

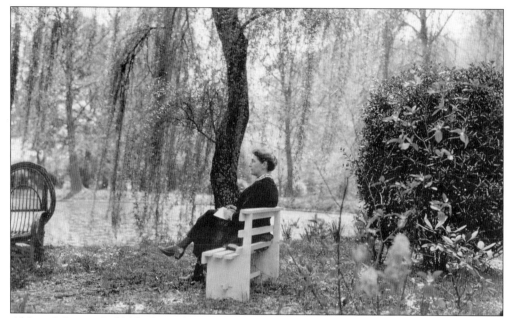

Although Lenna Judd liked to relax under the willows near the spring that fed the pond, she was an involved person. Her interests included the treatment of tuberculosis and cancer. Her generosity made possible the establishment of a cancer control clinic at the Hamilton Memorial Hospital, which became the Judd Cancer Center. (Courtesy of the Myers family.)

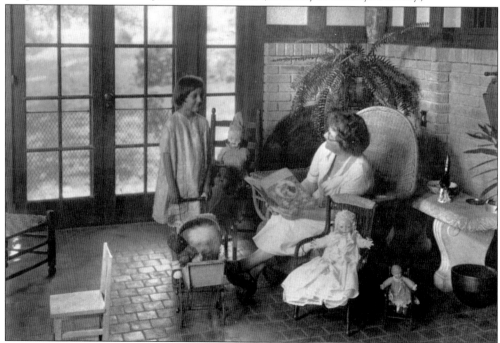

The Garden Room provided Lenna Judd a sunny location to read to her granddaughter Gertrude. Most homes in the 1920s did not have a large interior fountain with running water, like the one that stood in the center of the room. During her time, the room was filled with plants, many of which had been potted in the gardens for inside use. (Courtesy of the Myers family.)

Lenna Judd's granddaughter Jane was a successful opera singer in New York City. Lenna played both the piano and organ and composed music. Robert Loveman was a close family friend, and she set his famous poem, "It's Raining Violets," to music. The 22-room manor became a showplace for antiques, tapestries, and artworks. (Courtesy of the Myers family.)

Oneonta was also a working farm on which cotton was grown by the laborers who came from the surrounding farms. The Dalton area had poor soil, but nevertheless, Lenna Judd was active in supporting the development of the land, and in doing so, she became vice president of the Georgia Farm Bureau for many years. (Courtesy of the Myers family.)

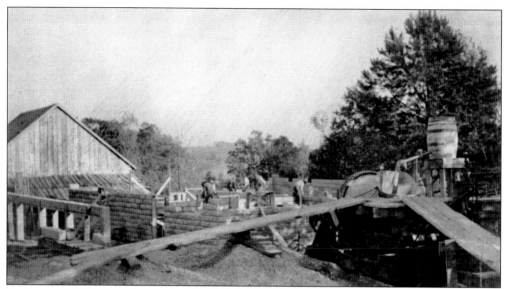

No farm would be complete without a barn. Clearly, one sees that this was a large structure. It was just to the west of the manor. When Evelyn Myers began the restoration of the property, the barn was turned into a nice home for her son Rick without harming the basic structural lines of the building. (Courtesy of the Myers family.)

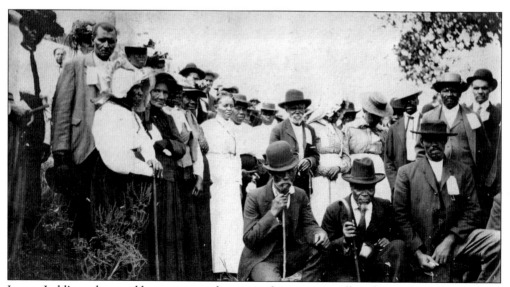

Lenna Judd's gardens and home attracted renowned visitors as well as these African Americans from the area. Standing in the center of this group is Levi Branham, a former slave who became the first black educator in northwest Georgia. In Lenna Judd's latter years, one servant, Louise Graham, became a caretaker for her. (Courtesy of the Myers family.)

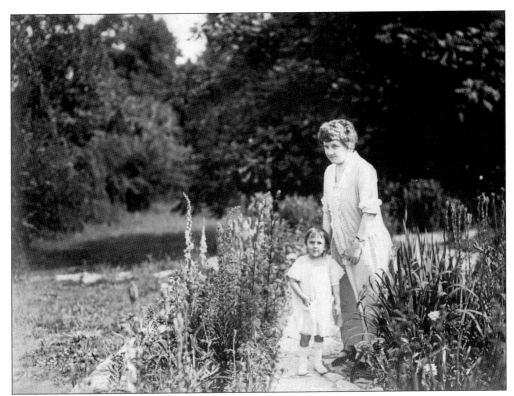

When Lenna Judd was not enjoying her gardens with her granddaughters, she was active in many charities. One of her most loved charities was the American Red Cross. She served as chairman of the Whitfield County chapter for 18 years. During World War I, she worked day after day in the Red Cross workroom, instructing and directing the making of surgical supplies. (Courtesy of the Myers family.)

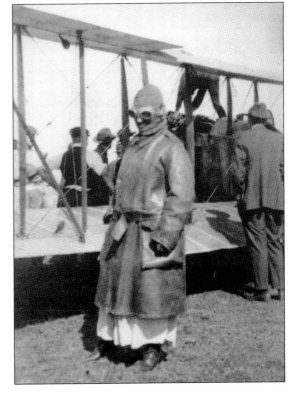

Lenna Judd was as much at home in the outdoors, be it riding her horses or directing the work in the fields, as she was entertaining important guests. She was also adventuresome. This is a picture of her in a leather coat, helmet, and goggles before her first and only airplane ride. This was before aviator Charles Lindbergh made his famous flight across the Atlantic Ocean. (Courtesy of the Myers family.)

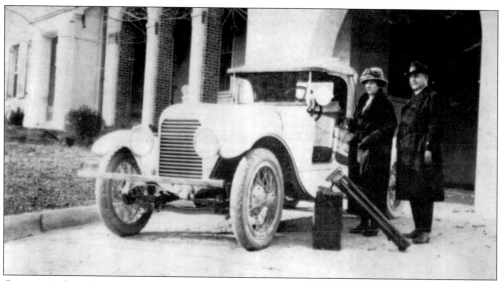

Oneonta's showplace appeal and Lenna Judd's reputation as a Renaissance woman attracted many visitors, some of which were quite unusual. For instance, a movie producer drove up from Atlanta with his camera and gear in this roadster to take pictures of the house and to put Lenna on film. (Courtesy of the Myers family.)

Lenna Judd passed away on February 2, 1939, at the age of 73. She and other members of the Judd family are buried in the West Hill Cemetery in Dalton. Her lovely home deteriorated and was shrouded in mystery behind razor wire and chain-link fences. In August 2000, Evelyn Myers bought the house from Lenna's grandson Morton and began to coordinate the huge restoration that saved the mansion. Expert designers were brought from all across the Southeast to return the house to its former grandeur. (Courtesy of the Myers family.)

Three

TRANSPORTATION

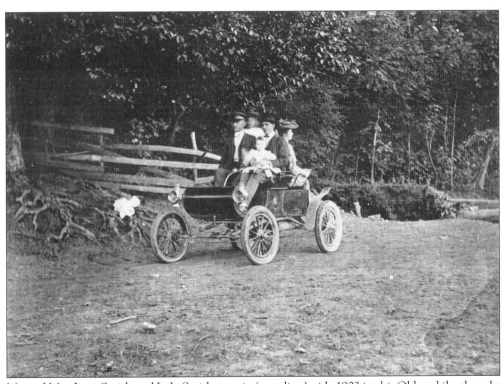

Mr. and Mrs. Jesse Smith and Lulu Smith, age six (standing), ride 1903 in this Oldsmobile, thought to be the first automobile in Dalton. Lulu Smith Westcott said her father may have invented seat belts, as he tied her and her brother to the seats with leather book straps. Local residents were amazed that the car could make it to Atlanta in a record 11 hours! (Courtesy of Georgia Archives, Vanishing Georgia Collection, Image No. WTF231.)

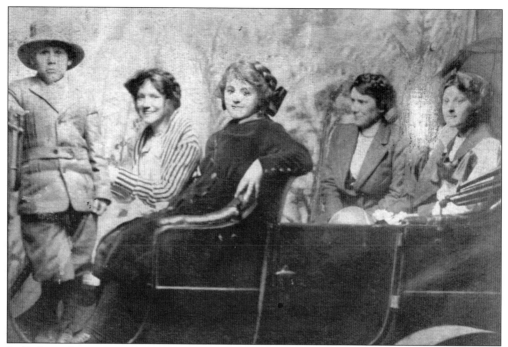

In Dalton, Georgia, in 1922, citizens journey on a blissful ride in an automobile of their era. Among those taking this ride on a Sunday afternoon are Gertrude Manly, who sits third from the left. (Courtesy of Anthony and Evan Pope.)

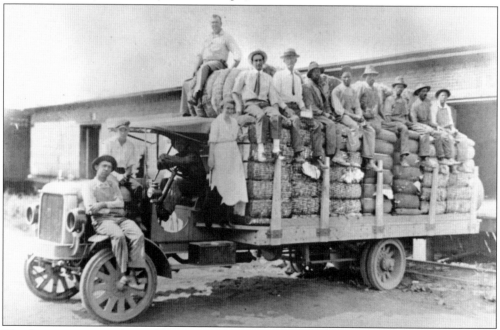

The first cotton ever shipped to Crown Mill is believed to have been brought by this truck. From left to right are Mark French, two unidentified, Fannie Brownlee, Carlton Brownlee, Lawrence Brownlee, Logan R. Pitts, and six unidentified members of the work crew. (Courtesy of Don Davis.)

Clint Burnette (on the hood) and Maribelle Burnette Richardson (on the roof) are posed on a vehicle on a dirt road in Dalton, Georgia. Clint was three years old, and Maribelle was one. This 1937 photograph reflects the transportation of that time, a late 1920s Ford Model A. (Courtesy of Betty Burnette Eller and Emily and Molly Poplin.)

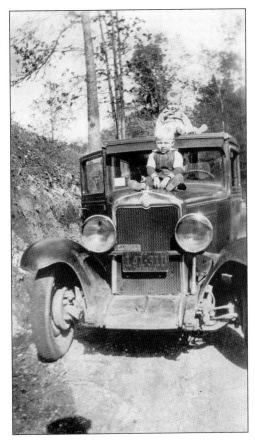

Jessie Hill's daughter sits behind the steering wheel of the family car during the early 1940s. Her unidentified friend is sitting on the passenger side as both girls smile for the camera. (Courtesy of Viola Guinn.)

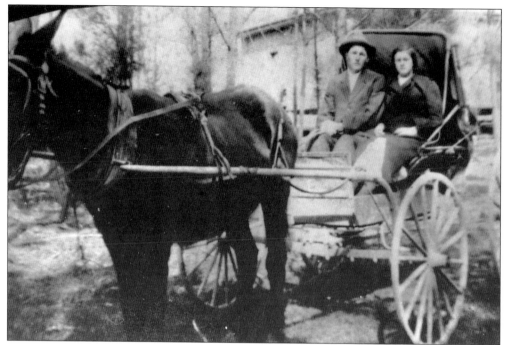

Lester and Mamie Flowers are pictured on the family farm in the Carbondale area on their wedding day ride in a horse-drawn carriage. Many citizens did not yet own an automobile at the time this 1915 photograph was taken. (Courtesy of Viola Guinn.)

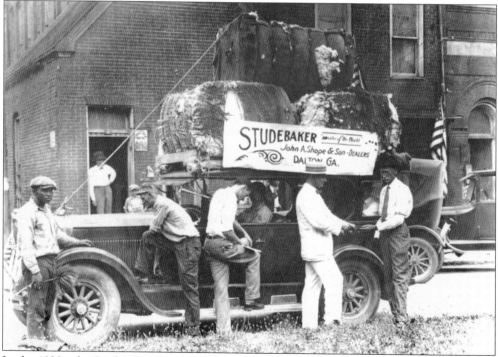

In the 1920s, the Studebaker was a popular car. Notice the cotton on the roof, another sign of the era. (Courtesy of *Bicentennial Book*.)

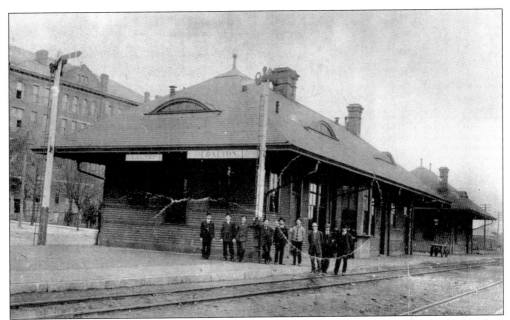

The Dalton Train Depot was built by the Western and Atlantic (W&A) Railroad in 1847, when the area was known as Cross Plains. This was the beginning of the tremendous growth of the city and served as a catalyst for Dalton's economic base. In the depot, the center of Dalton was defined in 1847. All land within a mile of this mark was in the newly named town of Dalton. The first train came from Atlanta with dignitaries on July 4, 1880. (Courtesy of Sherry Cady.)

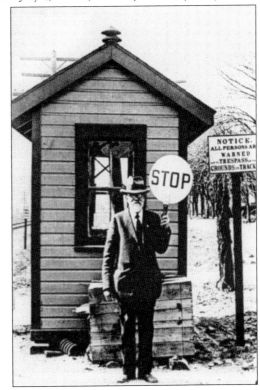

Thomas McBryde, a train watchman during the 1930s, stands in front of a train station holding a stop sign. He was born on November 2, 1843, in Atlanta and served in the Civil War. He later settled in Dalton, where he was a train watchman on Selvidge Street until the age of 90. Notice the sign to the right. (Courtesy of *Bicentennial* Book.)

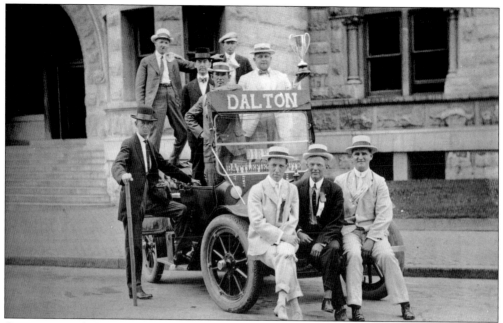

Competing with Rome for Highway 41 in 1914, a motorcade was formed to promote Dalton. At left, holding a cane, is Tom Boaz. Wearing a hat and standing in the back of the car on the far left is J. C. McLellan beside J. J. Copeland. Dr. H. L. Jarvis wearing a bow tie, and Louis Crawford is leaning on the sign. Paul B. Fite is holding the trophy cup. Seated on the bumper from left to right are Frank S. Rudent, B. A. Tyler and a Mr. Bishop. (Courtesy of Georgia Archives, Vanishing Georgia Collection, Imagine No. WTF273.)

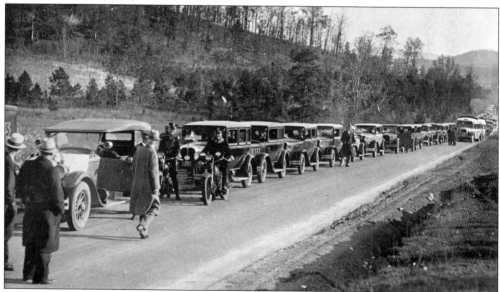

Citizens celebrate the completion of Highway 41, which opened to traffic in 1929 with a 150-car motorcade led by Georgia governor Lamartine Griffin Hardman. The highway ran from Atlanta through Dalton to Chattanooga, Tennessee. This highway was known as "Bedspread Boulevard" or "Peacock Alley" during the 1930s and 1940s because the street was lined with bedspreads for sale. (Courtesy of Georgia Archives, Vanishing Georgia Collection, Imagine No. WTF184.)

Four

SPECIAL EVENTS

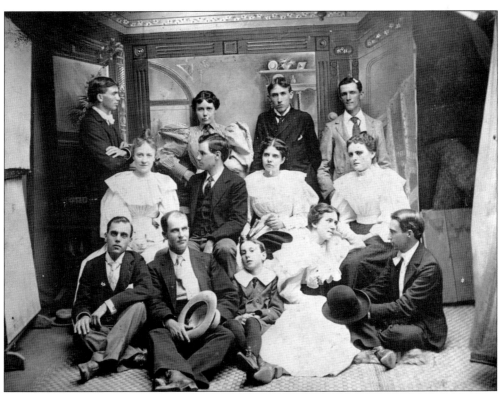

Entertainment was evident in the 1890s with the cast of a play striking a pose. Cast members include, from left to right, (first row) John Thomas, Will Prater, Barrett Denton, Mary Lynn, and Frank Dubois; (second row) Ruth Allen, Ed Davis, Hattie Thomas, and Kate Hamilton; (third row) Dennis Barrett, Dot McCamy, Mack Senter, and Walter Davis. (Courtesy of Georgia Archives, Vanishing Georgia Collection, Imagine No. WTF021.)

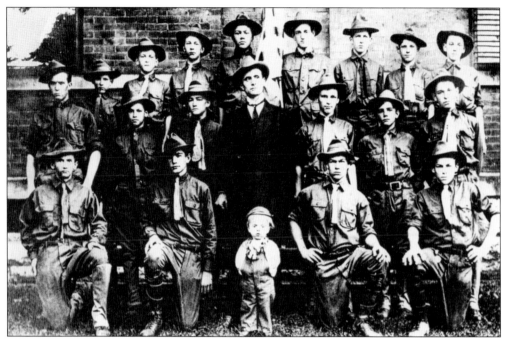

The year 1911 marked the beginning of the first Boy Scout troop in Dalton. The troop leader was W. M. Sapp Sr., who with his troop placed the permanent marker on George Disney's grave. Disney, a member of Company K in the Kentucky infantry, was a Confederate in the Civil War who was buried where he fell in the war. (Courtesy of Sherry Cady.)

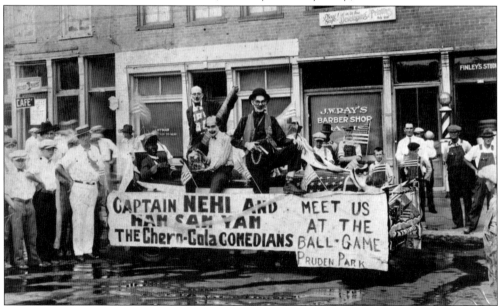

A parade float in 1925 is parked in front of what is now 212 Hamilton Street. The Chero-Cola comedians, Caption NeHi and Ham SamYam, are aboard the float. Spectators are impatient to meet these comedians at the ball game in Pruden Park. In the background are J. W. Ray's Barber Shop and Finley's Studio. (Courtesy of Georgia Archives, Vanishing Georgia Collection, Imagine No. WTF038.)

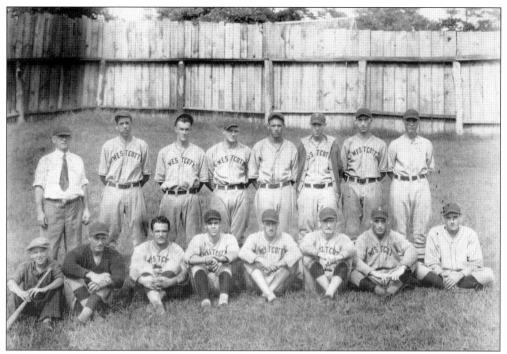

The Westcott Hosiery Mills organized and sponsored a baseball team in 1929. The team members are, from left to right, (first row) Burl Williams, "Lefty" Sproul, Claude White, Clyde Roberts, Charlie Canfield, Jimmy Bradshaw, D. Caldwell, and Troy Hogan; (second row) manager Claude Williams, Jess Roberts, Milton Haley, "Chigger" Reese, Harold Bennett, Virgil Roberts, Carson Beck, and "Red" Caldwell. (Courtesy of Hal Millsaps.)

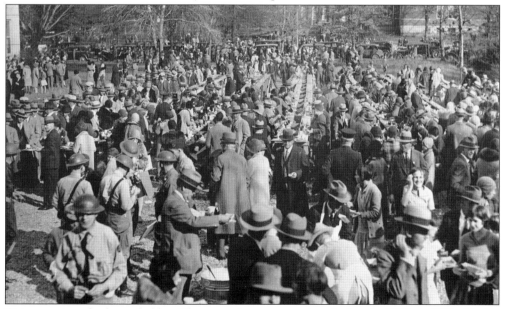

Citizens enjoy a barbecue held on Thornton Avenue sometime during the 1920s or 1930s. Notice the soldiers and the automobiles in the background. (Courtesy of Georgia Archives, Vanishing Georgia Collection, Imagine No. WTF185.)

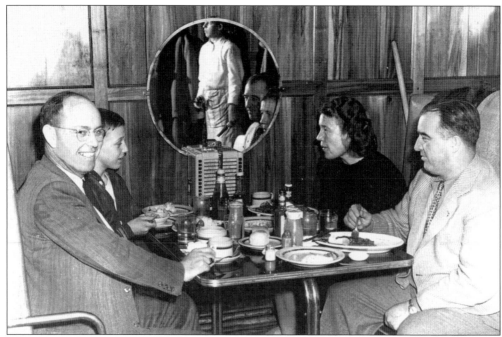

Happy Chandler, left, is shown eating at the U.S. Café. Chandler ran for governor of Kentucky in 1935. He resigned in 1939 and became a U.S. senator and later became the commissioner of a major league baseball team, the Brooklyn Dodgers. He was Kentucky's governor again from 1955 to 1959 and was added to the Baseball Hall of Fame in 1957. (Courtesy of Sherry Cady.)

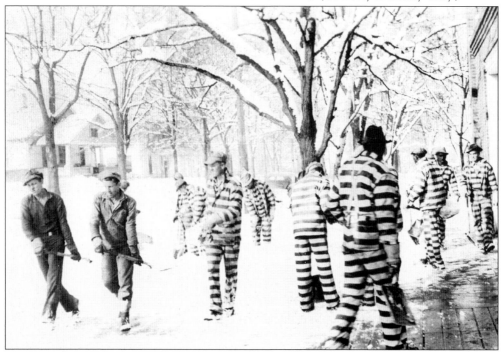

In 1940, a blizzard hit Dalton. Convicts, clad in their stripped uniforms, shoveled the streets. (Courtesy of Sherry Cady.)

A picture-perfect snow scene is captured in the late 1940s. The house to the far left is the Robert Loveman home place, which at one time served as Dalton's library. Two beautiful homes were torn down to open up and continue Waugh Street. The Loveman House was later torn down due to disrepair. (Courtesy of Sherry Cady.)

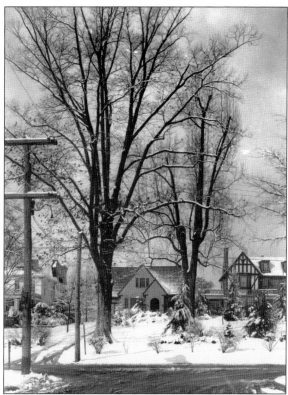

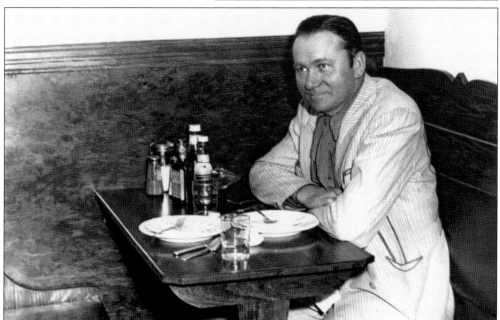

Tex Ritter, a well-known country music singer and actor, is shown eating at the Oakwood Café in Dalton. He was known as the "Singing Cowboy." Ritter, who was born on January 12, 1905, got his first movie contract in 1936. Most of his movies were Westerns. He died on January 12, 1974, in Nashville, Tennessee. (Courtesy of Sherry Cady.)

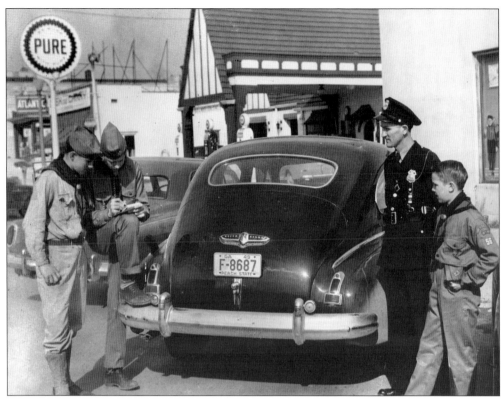

In 1949, the Boy Scouts were given the opportunity to run the town for a day. They are seen above writing a parking ticket while a Dalton policeman stands nearby in a supervisory capacity. A Pure service (gas) station is pictured in the background. (Courtesy of Georgia Archives, Vanishing Georgia Collection, Imagine No. WTF178.)

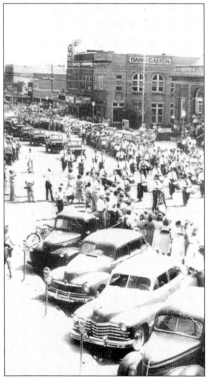

One of the many World War II victory parades occurred in downtown Dalton. The young man pictured at left on the bicycle is Leon Helton, the owner of the Helton Tire Center. The old cars and the back of the pickup truck provide great spots for viewing the parade. In the background are the Wink Theater, the Bank of Dalton, and the post office. (Courtesy of Sherry Cady.)

Five

African Americans in Dalton

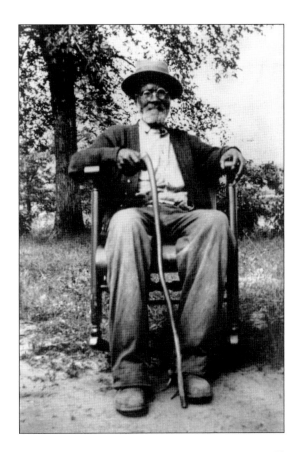

The first African Americans that came to north Georgia acted as "waitmen and waitresses" for their owners. Born in 1852, Levi "Boisey" Branham was taught to read and write by "two white ladies," as he recalls in *My Life and Travels*. With emancipation, he was called upon to teach area children and continued to do so until he died in 1944. In 1990, the Murray County Central Office building was named for him. (Courtesy of Curtis Rivers.)

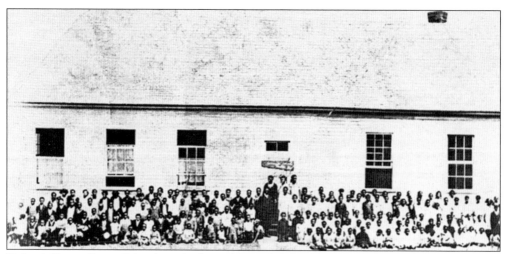

Dalton's Emery Street School was built in 1887 with federal money so the 263 black children in Dalton from the ages of 7 to 16 could attend school through the seventh grade. If black children from the nearby counties wanted to finish the higher grades, they came here. A fire in 1909 ravaged the building, but it was restored, continuing to service children from kindergarten to 11th grade until 1968. (Courtesy of the Emery Center.)

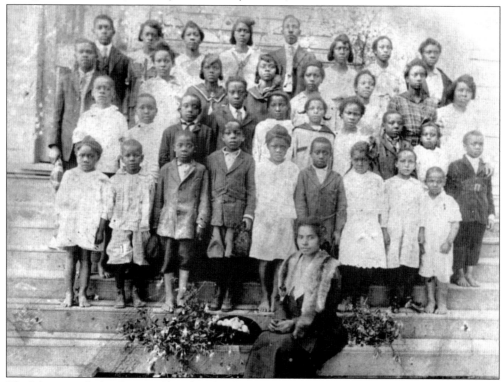

The Mountain Ridge Baptist Church School was representative of small church schools. Luella Walker Hardiman was the teacher of this 1920s group. Many of the children did not have shoes. During this decade, Whitfield County had 42 home schools for white children and six for black children. By the 1940s, only three of the African American schools were still in existence. (Courtesy of the Emery Center.)

The Emery Street School provided an excellent education. By 1941, it was the only African American school accredited in the state. When schools were integrated, it became the City Park Middle School. In 1999, there were plans to demolish it, but a concerned group of blacks were able to persuade the city to maintain the school as a center for the preservation of black history. (Courtesy of the Emery Center.)

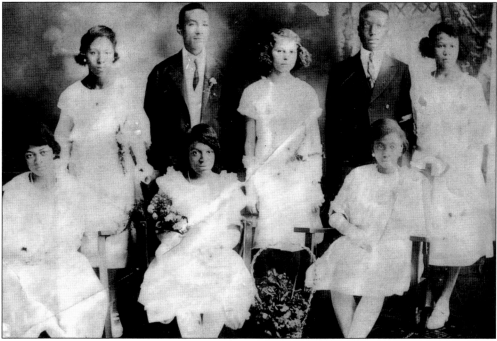

The May 1928 graduating class only went through the seventh grade. Pictured are, from left to right, (first row) Inez Sapp, Lucy Mae Walker, and Mattie J. Johnson; (second row) Essie M. Stokes, Reverend Stroud, Ester Jackson, Richard Tolliver, and Charlotte Hardwick. Reverend Stroud was both the acting principal and the pastor of Bethel A.M.E. Church. (Courtesy of the Emery Center.)

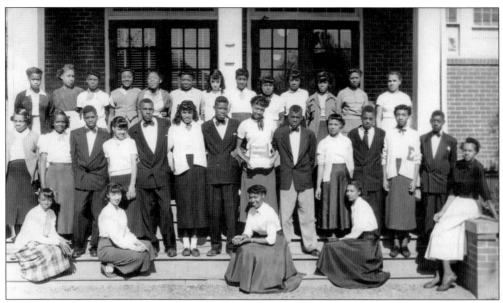

This *c.* 1952 class picture was taken of all the upper classes together, since they did not take individual class pictures. At that time, the classes were very small. Curtis Rivers, director of the Emery Center, started in the third grade with 33 in his class and finished with only 11. Many quit to go to work or to join the military. Some simply dropped out. (Courtesy of the Emery Center.)

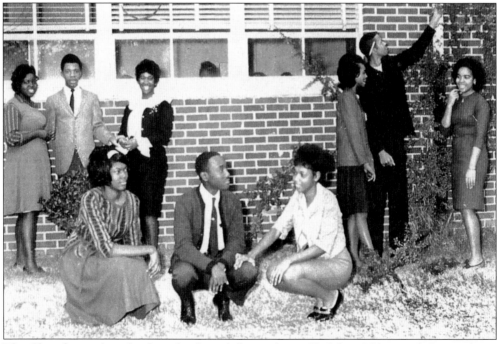

The *Cheetah* was the school yearbook, and this is the staff of the 1966 annual. Pictured are, from left to right, (first row) Joyce Walton, art editor; Kenneth Caldwell, business manager; and Gwendolyn Johnson, assistant editor; (second row) Rose Banks, proofreader; Perry Baker, sports editor; Glenda Shropshire, editor-in-chief; Maxine Broomes, subscription manager; Larry Austin, photographer; and Mary Morris, advertising manager. (Courtesy of the Emery Center.)

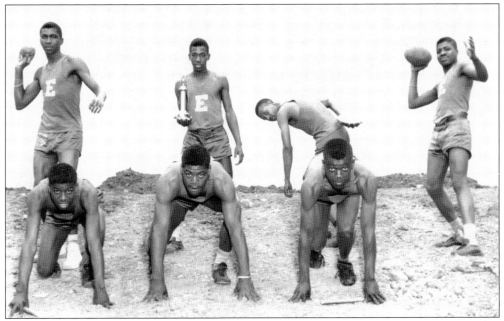

Track and basketball were the only two sports in which the school was able to participate. This picture of the seven track members is from the early 1950s. They competed against the area black schools and won trophies in conference play. Basketball was played on the regulation dirt court behind the school, and the uniforms were T-shirts and jeans. (Courtesy of the Emery Center.)

The Shiloh Baptist Church was organized in the late 1800s in Murray County but moved to Dalton in 1972 when many of its members moved to Whitfield County to work in the carpet industry. It provided a site for a church school for black students. Its present sanctuary on M. L. King Jr. Boulevard was built in 1987. (Courtesy of the Emery Center.)

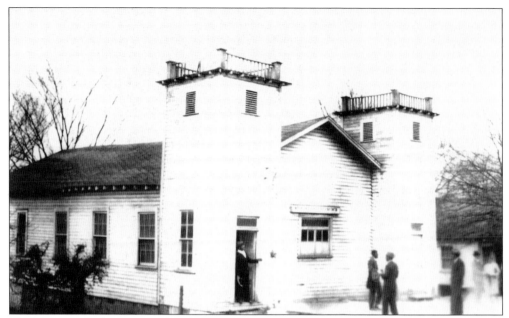

The Mountain Ridge Baptist Church was organized on May 1, 1868, in a hilly section of Whitfield County and became active in establishing new churches. In 1878, four of the pastors left to form new churches. Mountain Ridge Baptist Church moved to Matilda Street in 1930 and finally to M. L. King Jr. Boulevard. In 2008, there were 18 black churches in the area. (Courtesy of the Emery Center.)

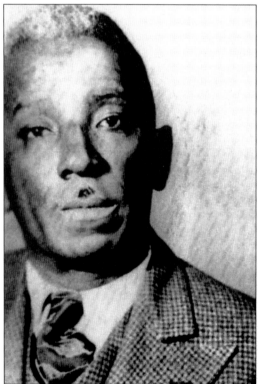

Clifford Taylor Sr. is representative of black businessmen. He was the owner of the Dalton Broom and Mop Factory, a city bondsman, and a member of the Masonic Order of Knights of Pythius. Black businesses included Gaston and Smith Heating, Sims' Beauty Salon, Sol's Barber Shop, Atlanta Life Insurance, Elsie's Beauty Shop, Dr. F. L. Russell, Day's Waste Paper, the Civic Club, and Dr. A. O. Sims. (Courtesy of the Emery Center.)

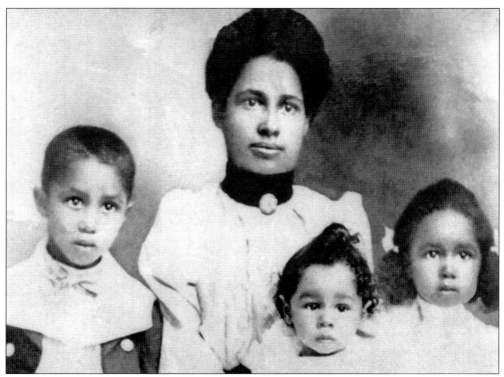

Sallie Sheffield Black was the mother of, from left to right, Lorenzo, Alberta, and Marie, and she worked for Col. W. C. Martin, a typical job for an adult black woman at the time. Another black woman, Eldora Davis, worked most of her more than 80 years for white families. In those years, most blacks lived around Emery Street, which became McCamy Street, as well as Pendley, Arthur, and Spring Streets. (Courtesy of the Emery Center.)

Gordon and Lula Bella Willis and their large family stand at the corner of Frederick Street and M. L. King Jr. Boulevard in the early 1950s. This lot is where the community center currently stands. When the circus came to town, it would set up the tents on this lot. (Courtesy of Mary Willis Suttles.)

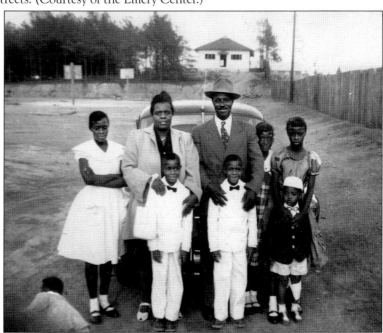

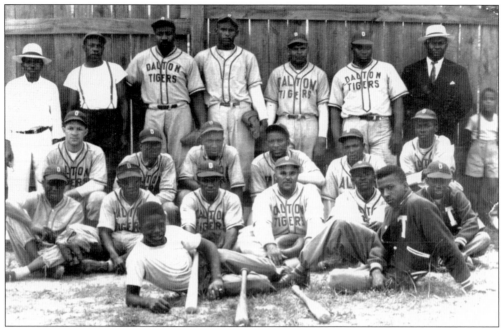

This is the Dalton Tigers team in 1947. From the 1930s to the 1960s, the Tigers played twice a week, plus on Sunday, against teams that had players who went on to play in the major leagues. Many young men started out as batboys for the team in grade school and worked their way up to positions on the team. (Courtesy of Frank Ray.)

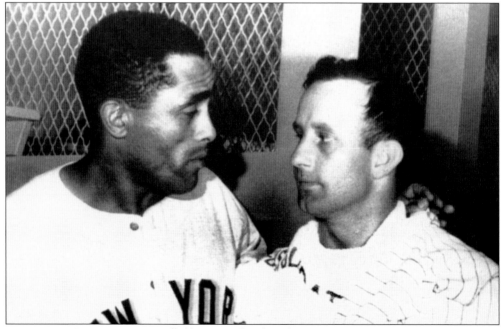

Harry Leon "Suitcase" Simpson (left), pictured with Bob Grim of the Yankees, grew up in Dalton and played for 17 teams in an 11-year career in organized baseball. He was the third black man ever to play for the American League, playing with the Yankees and Indians. He had his best season with Kansas City with a .293 batting average. (Courtesy of the Emery Center.)

Mel Pender (pictured winning the race) was born on Spring Street and later moved to Atlanta. While serving in the U.S. Army in Vietnam, he discovered his natural talent for track. He set a number of world records, and in the 1968 Olympics, he won a gold medal in the 4-by-100-meter relay. Pender was the head track coach at West Point and was named to several halls of fame. (Courtesy of the Emery Center.)

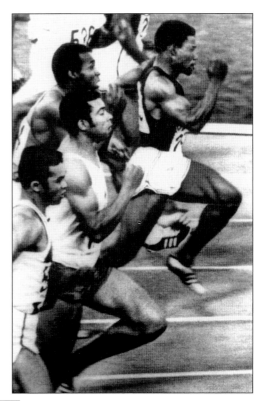

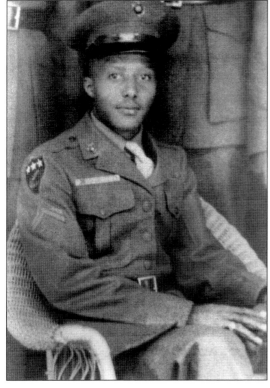

William J. Willis was the first black marine from Dalton. After attending the Emery Street School, Willis attended Morehouse College. He served in the Pacific theater. At the end of the war, he became the supervisory embalmer for the new Punchbowl National Cemetery in Hawaii. He came to Dalton in 1957 and established the Willis Funeral Home. (Courtesy of the Emery Center.)

T4 Sgt. Monroe P. Blackwell of Dalton fought in World War II, landed in Europe on D-Day, and then later transferred into the air force (1951–1968). He served in Vietnam, attaining the rank of master sergeant. At the age of 85, Blackwell lectured at the Emory Center in his military uniform, which he could still wear. (Courtesy of the Emory Center.)

Rear Adm. Mack Gaston, shown with his wife, the former Lillian Juanita Bonds of Dalton, was also born in Dalton in 1940. He graduated from the Tuskegee Institute with a degree in electronics. He began his career in the navy with tours in Vietnam. In this picture he is assuming command of the USS *Cone*. He retired after becoming a rear admiral and serving in command headquarters. (Courtesy of the Emory Center.)

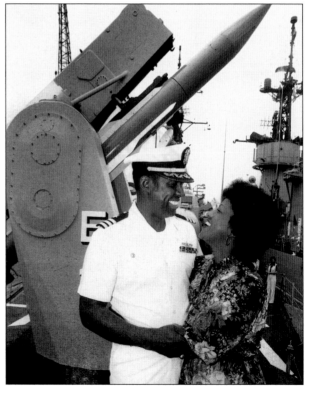

Six

CHURCHES

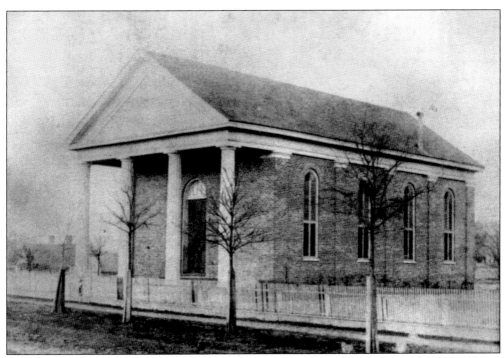

Edward White gave lots for Presbyterians, Baptists, and Methodists to construct church buildings, but the congregations first shared a small building called the Town House. The Presbyterians bought the Town House. They were the first organized church in the city, having been founded on October 31, 1847. John Jones was the first preacher. His congregation consisted of five men, six women, and one young slave boy. The original frame building was destroyed by Union soldiers before they withdrew from Dalton. In 1868, this small red brick building was built; the steeple was added in 1893. (Courtesy of Anthony and Evan Pope.)

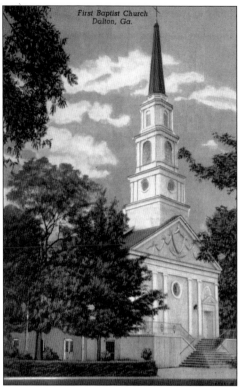

First Baptist Church
Dalton, Ga.

The First Baptist Church, established on November 29, 1847, is pictured after it was renovated in 1952. It was located on the corner of Selvidge and Waugh Streets. The first pastor was George W. Selvidge, from 1848 to 1853. The 1,700-pound bell was given to the church in 1857 and was sent to Macon for safekeeping during the Civil War. It was returned in 1872 and now sits in the bell tower of the present sanctuary, which opened in 1959 on Thornton Avenue. (Courtesy of Bruce Davies.)

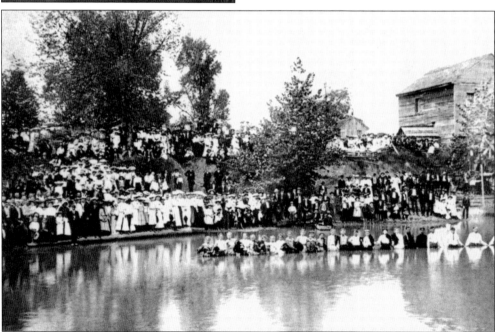

Before heated baptismal pools in churches, baptisms took place in nearby creeks or ponds. Since these could only be held in warmer months, there was usually a large group to be baptized. This large group baptism took place at Keith Creek along Cohulla Creek around 1900. Notice the large hats and white dresses of the women. (Courtesy of *Bicentennial Book*.)

St. Mark's Episcopal Church began in 1867. Services were held in the courthouse until a church was built on Glenwood Avenue. The old church was destroyed, and the wood was used to construct the new building on North Pentz Street. Later the original cornerstone was found and reinstalled, and the altar was found being used as a cutting block in a butcher's shop. St. Mark's held its first service in its present location on West Emery Street in 1965. (Courtesy of Sally Huggins.)

After sharing a small frame building with the Presbyterians and Baptists, Methodists erected a frame building on the corner of King and Selvidge Streets. In the fall of 1851, Levi Brotherton first preached in this new church, which was replaced with a brick one after the Civil War in 1867. In 1872, a church bell was added. The bell is now in front of the present sanctuary, which was dedicated in 1951 and is located at 500 South Thornton Avenue. (Courtesy of *Bicentennial Book*.)

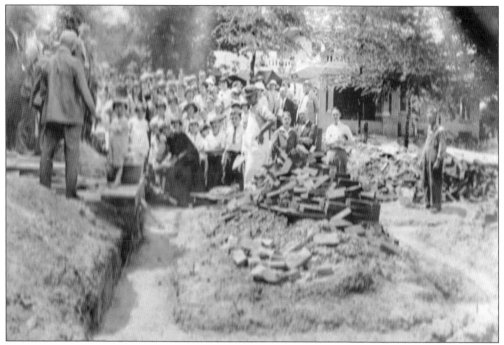

Members of First Methodist Church gathered in 1924 or 1925 at the corner of Thornton and Cuyler Streets to lay the cornerstone for a new parsonage. This structure later became Davies Jewelers. (Courtesy of Taylor Boyette.)

The last couple to marry in the old First Baptist Church on Selvidge Street was Phyllis Edwards and Richard Dix, who wed on June 20, 1959. (Courtesy of Denise Dix.)

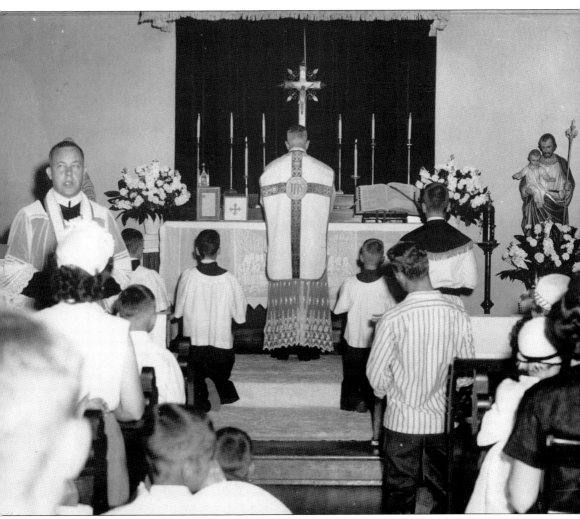

The beginnings of the Catholic church in Dalton date back to the late 1800s with Irish immigrant railroad workers. The bishop of Savannah, Francis Xavier Gaitland, purchased land on July 1, 1852, from the Dalton City Company. The church, seized by Federal troops and used as a military hospital for smallpox victims, was burned after the Civil War to prevent the spread of disease. Another church was built, but the parish became inactive, and the building was sold in 1922. In 1942, the Duff Green House was purchased and remodeled to hold mass. A new church was later built on the property beside the house. In 1949, the Council of Vatican I guided the Catholic Church. At this time, mass, which was spoken in Latin, was longer and more formal, and communion was prepared facing the altar. Here Fr. Norman Rockwood says mass, and Fr. Bernard Krimm assists. Mass is being held in the "Old House." After Vatican II, the priest began to prepare the communion facing the parish, which is still done today. (Courtesy of St. Joseph's Catholic Church and Wyatt Cushman.)

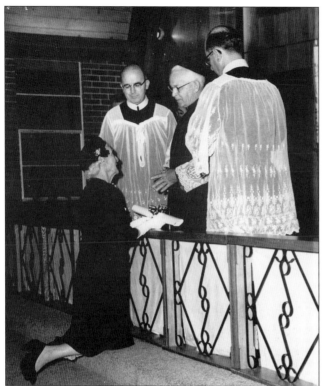

The Wrench sisters, Alice, Effie, and Frances, the daughters of Henry Wrench II, were instrumental in the rebirth of the Catholic church in Dalton. Alice taught religious education in the "Old House" until the sisters came from Fort Oglethorpe, Georgia, to assist. Pictured here on April 22, 1958, is Alice Wrench, who received a papal medal from Pope Pius XII for her long, unselfish service to the church. (Courtesy of St. Joseph's Catholic Church and Wyatt Cushman.)

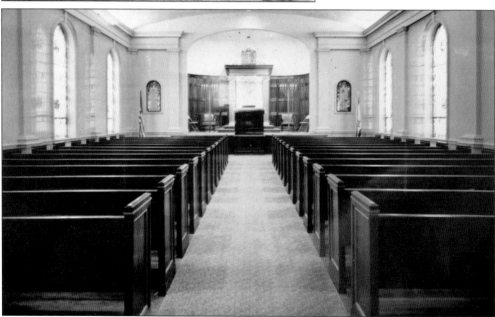

This photograph shows the sanctuary of Temple Beth-El, a Jewish synagogue, in 1951. In 1938, Jewish families joined together to hold services at the Loveman Library. The Loveman family, the first Jewish family in Dalton, arrived in 1865. As the Jewish population increased, thanks to the chenille industry, Temple Beth-El was constructed and was dedicated on March 9, 1947. (Courtesy of Georgia Archives, Vanishing Georgia Collection, Image No. WTF117.)

Seven

BUSINESSES

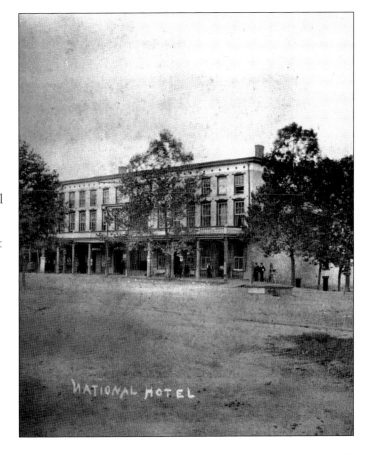

This Finley's Studio photograph of the National Hotel, located at the corner of Crawford and Hamilton Streets, was built around 1851. During the Civil War, it was rented to the Confederate Medical Service. Under Union occupation, it was used as a hospital, commissary, prison, headquarters, and stable. It was torn down to build the Hotel Dalton. (Courtesy of Georgia Archives, Vanishing Georgia Collection, Image No. WTF026.)

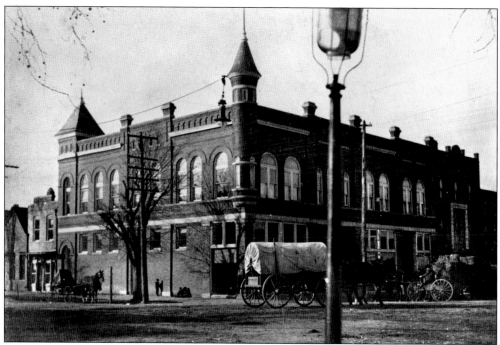

The Cannon Building, pictured around 1911, was located at the corner of Hamilton and King Streets and was a distinctive landmark with its corner tower. The dry-good store was built in the 1870s and was owned by four generations of the Cannon family, including the family of William Ragsdale Cannon. The original building burned in the 1950s and was rebuilt. (Courtesy of Georgia Archives, Vanishing Georgia Collection, Image No. WTF232.)

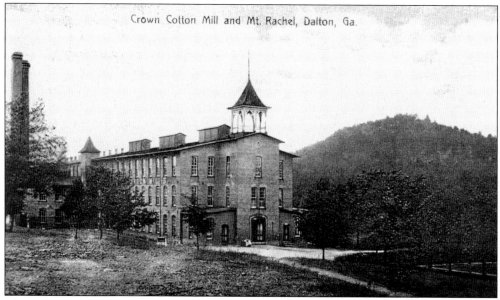

The Crown Cotton Mill, built in 1884, was the first large company in Dalton. Behind the plant is a railroad track, which local folklore says covers the grave of former land owner Chief Young Bird. By 1888, the mill sold goods to New York and Philadelphia. Hamilton House, which was used as an office, now holds the Crown Garden and Archives. (Courtesy of Hal Millsaps.)

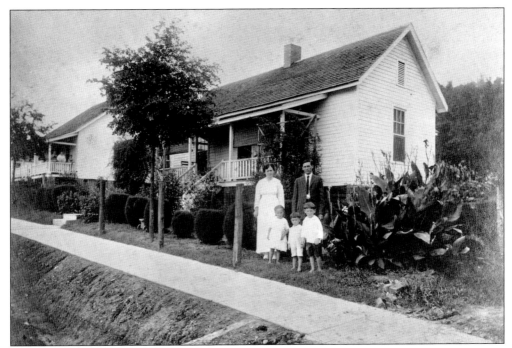

The Crown Mill Village, started in 1886, included a company store, an office, and small cottages for employees. The company later built a school and a church for its employees. In this 1919 photograph, a family poses in front of their mill house on Chattanooga Avenue as the winners of a contest to determine the most attractive yard. (Courtesy of Georgia Archives, Vanishing Georgia Collection, Image No. WTF261.)

The Boylston Cotton Mill was located on South Hamilton Street. (Courtesy of Arnold King.)

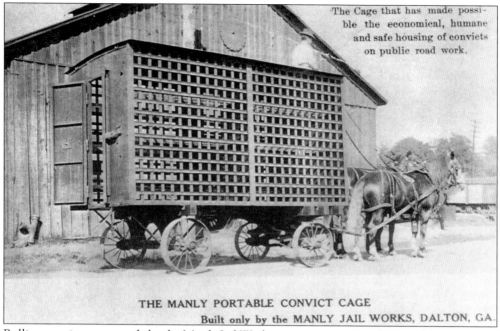

The Cage that has made possible the economical, humane and safe housing of convicts on public road work.

THE MANLY PORTABLE CONVICT CAGE
Built only by the MANLY JAIL WORKS, DALTON, GA.

Rolling convict cages, made by the Manly Jail Works, were an economical way to house convicts at their work site. In 1888, the company began building bridges, machinery, decorative ironwork, and jail cells. Thirty carloads of iron fencing were sent to the Chicago World's Fair. Today the company is known as Manly Steel and continues to be the oldest manufacturing company and business in Dalton. (Courtesy of Judson Manly.)

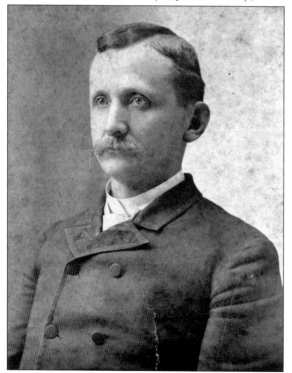

A. J. Showalter, pictured around 1885, was a musician, composer, and teacher who built a printing empire on shape-note music in the late 1800s. In 1890, he established the A. J. Showalter Company: Printers, Binders, and Music Publishers, which printed hymnals, songbooks, magazines, newspapers, and schoolbooks. His song "Leaning on the Everlasting Arms" was one of the most popular gospel songs of the 20th century. (Courtesy of Georgia Archives, Vanishing Georgia Collection, Image No. WTF028.)

Theron S. Shope, pictured around 1905, was the editor of the *Dalton Citizen* from 1903 to 1936. Shope was born in Ellijay in 1847 and died in Dalton in 1936. His portrait hangs in the Hall of Fame at the Henry W. Grady School of Journalism at the University of Georgia. His daughter, Helen Shope, was the first female air traffic controller in the United States. (Courtesy of Georgia Archives, Vanishing Georgia Collection, Image No. WTF044.)

Hotel Dalton, shown below in 1900, was located at the corner of Crawford and Hamilton Streets. It was built in 1890 on the site of the National Hotel. Located to the right was the opera house. Both were destroyed by fire. The hotel was rebuilt in 1923, but the opera house never reopened. The vacant lot later housed the post office in 1909. (Courtesy of Georgia Archives, Vanishing Georgia Collection, Image No. WTF080.)

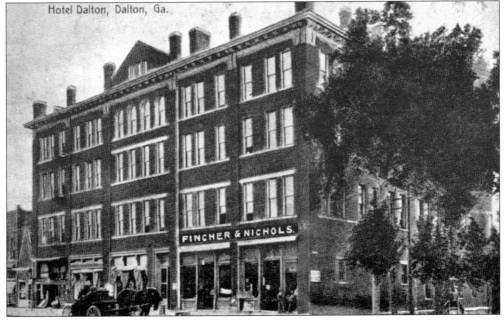

Ivan Allen, one of Dalton and Georgia's most notable citizens, was born in 1877. He moved to Atlanta in 1895. Allen founded the office outfitting company Ivan Allen–Marshall Company, where he made his fortune. He was an organizational genius, a pioneer in early industry, a philanthropist, and a state senator. The Allen family donated the land for Fort Mountain State Park. (Courtesy of Georgia Archives, Large Print Collection, Image No. LPC010.)

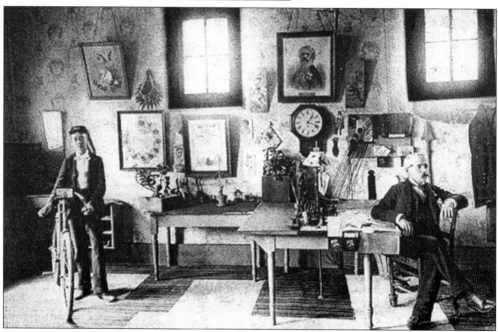

The Dalton telegraph office, which is currently the bar at the Depot Restaurant, was located in the depot at the end of Crawford Street. Pictured in this May 15, 1896, photograph is the interior of the office, complete with furnishings and telegraph equipment. From left to right are Marvin G. Rogers and Charles H. Snow. Rogers delivered telegrams. (Courtesy of Sherry Cady.)

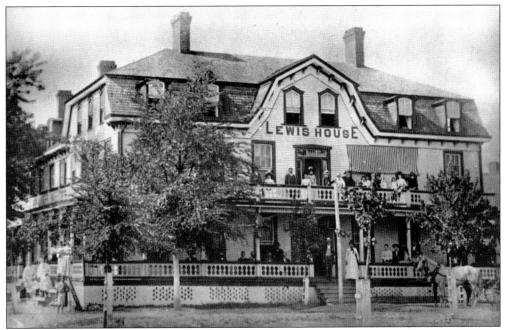

The Lewis House Hotel was located on Crawford Street near the depot around 1890. Guests pose for a photograph at this resort hotel. In the 1890s, people came from south Georgia and Florida during the summer and from the North during the winter. The Lee Printing Building sits in its place today. (Courtesy of Georgia Archives, Vanishing Georgia Collection, Image No. WTF116.)

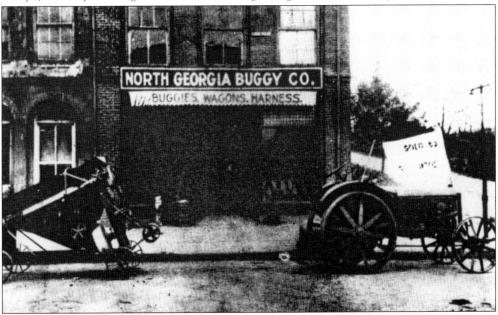

In the days before automobiles, businesses like the North Georgia Buggy Company, pictured around 1919, sold buggies, wagons, and harnesses. Owned by Benjamin Durham and located on Hamilton Street, it was one of the first businesses in the area. The company sold the first Winona Wagon in Georgia. The machinery on the right is an early tractor. (Courtesy of Georgia Archives, Vanishing Georgia Collection, Image No. WTF306.)

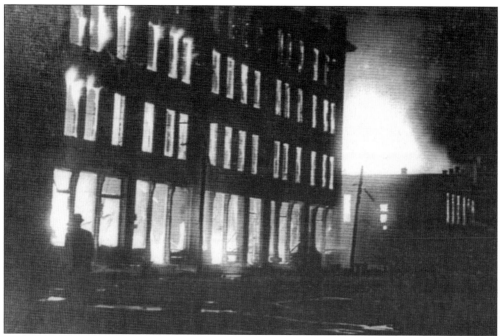

On April 9, 1911, a fierce fire swept through the heart of downtown Dalton. It was one of the worst disasters to strike the community, destroying half of downtown. The fire began around midnight on the third floor of the Hotel Dalton, just above the kitchen. The fire claimed 10 buildings, including the massive four-story Hotel Dalton, the Showalter Publishing Company, the Queen Opera House, and the North Georgia Buggy Company. (Courtesy of Randy Bates.)

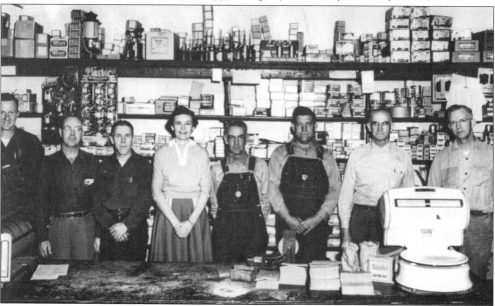

Fraker Hardware, which was started in 1915 by Clarence Fraker, was in business on the corner across from the present-day Wachovia Bank. Fraker's Hardware was the place where farmers came to town to do their shopping on Saturdays. The company was in business for 85 years before closing. (Courtesy of Sherry Cady.)

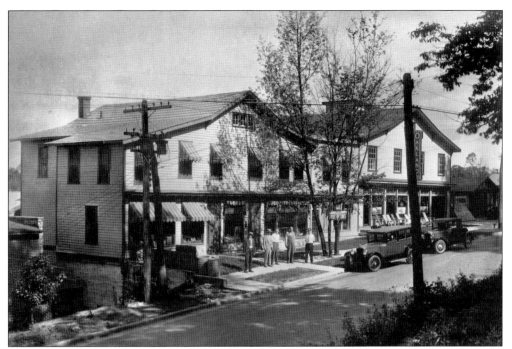

Acme Lumber, owned by Pete Lumpkin, was located on North Thornton Avenue. Above the lumber company were second-floor apartments. The city's swimming pool was next door. (Courtesy of Georgia Archives, Vanishing Georgia Collection, Image No. WTF304.)

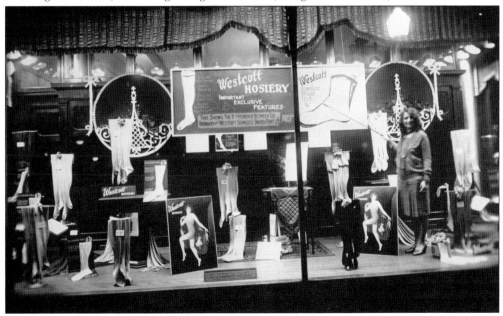

This Westcott Hosiery Mill store window displays some of the full-fashion hosiery products made in Dalton from 1917 to 1929. Products included silk hose, undergarments, and lingerie. Located on North Hamilton Street, the business was owned by G. Lamar Westcott and was sold just before the stock market crash of 1929. (Courtesy of Georgia Archives, Vanishing Georgia Collection, Image No. WTF335.)

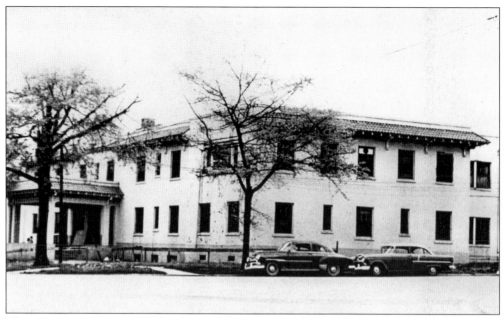

The influenza epidemic of 1918 influenced the community to build a hospital to care for the sick. Built in 1921, it was named the Hamilton Memorial Hospital in memory of George Hamilton. With four wards, a fully equipped X-ray room, and an operating room, it could care for 32 patients. Pictured here in 1956, it was the first air-conditioned hospital in the state of Georgia. (Courtesy of Sherry Cady.)

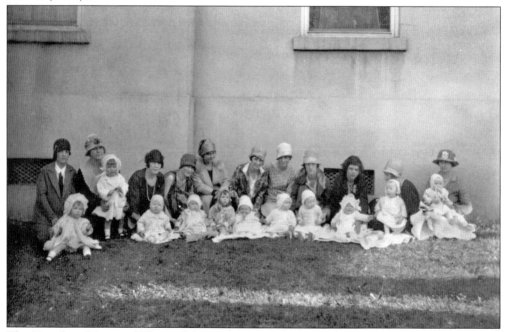

The Hamilton Memorial Hospital, located on Waugh Street, began delivering babies around 1926. Shown here are some of the first babies born at the hospital, along with their mothers. The hospital was initially built to care for Crown Mill employees and later served the community. (Courtesy of Georgia Archives, Vanishing Georgia Collection, Image No. WTF182.)

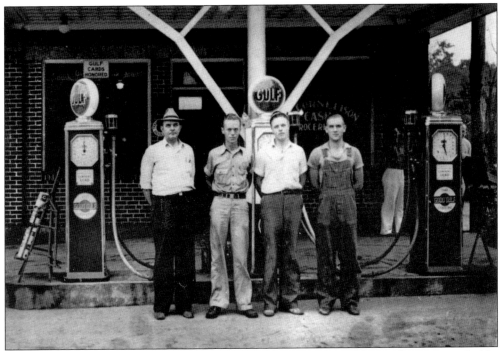

As automobiles become more prevalent in the Dalton area, the need for gasoline was satisfied by local grocery stores and family-owned gas stations. Cornelison Grocery was established in 1925 and was located on Highway 41. Shown from left to right are store owner Jesse A. Cornelison, Tom King, Herschel Cornelison, and Arthur Travillian. (Courtesy of Jordan Quarles.)

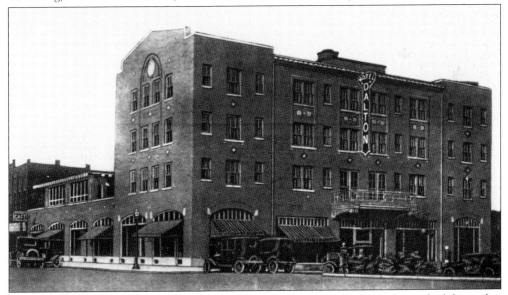

The Hotel Dalton shown here in 1923 was built to replace the first Hotel Dalton, which burned in 1911. At the time, it could boast to be the only fireproof hotel between Atlanta and Chattanooga, Tennessee. The hotel had a lovely rooftop garden where dances were held. Now known as the Landmark Building, it was Dalton's first "skyscraper" with four floors. A fifth floor was added later. (Courtesy of Randy Bates.)

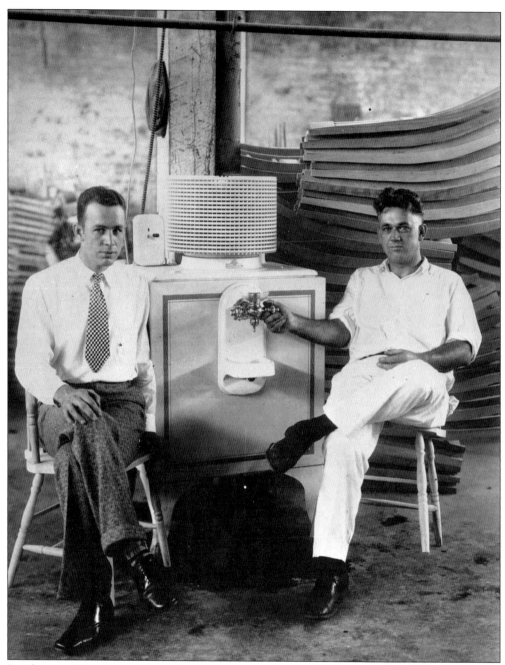

Employees of the Duane Chair Company, pictured around 1930, sit near the company's new refrigerator, providing water for workers. The company started producing chairs in 1903 on Glenwood Avenue. By 1904, the company was making 1,400 chairs per day in 160 varieties and employed 140 skilled workers. The business was destroyed by fire in 1916, was rebuilt in 1920, and closed permanently in 1940. (Courtesy of Georgia Archives, Vanishing Georgia Collection, Image No. WTF327.)

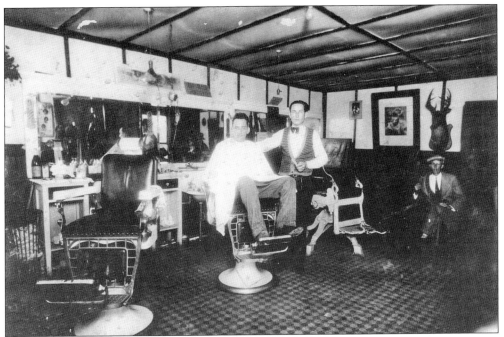

Claude Posten and an unidentified customer are pictured in his barbershop in the 1930s. (Courtesy of Betty King Posten and Mable McKone.)

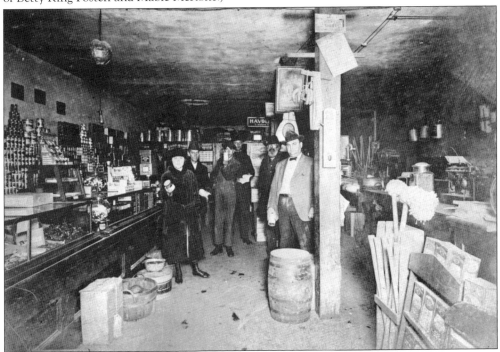

The Stacy Brothers Grocery Store, pictured around 1936, was typical of grocery stores of that era. Note the merchandise offered for sale. The owners were Osborne Stacy (fourth from the left) and Carter Stacy (far right). (Courtesy of Georgia Archives, Vanishing Georgia Collection, Image No. WTF251.)

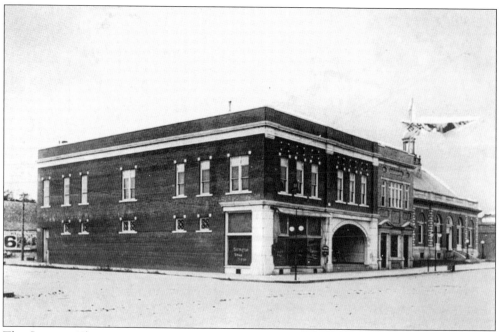

The Crescent Theater ushered in the era of talking movies to Dalton during the 1920s. Located on Hamilton Street, it was owned and operated by Manning and Wink, with J. C. H. Wink as the general manager. The theater seated 700. It had an RCA phonophone sound system, an electric piano with 72 tunes, and changed movies daily. It was in business for 21 years. One of the most notable features was the theater's unique alcove entrance. The building burned in the 1960s. Before the Crescent, there was a silent-movie theater, the Shadowland, located where the Wink Theater is today. (Courtesy of Sherry Cady.)

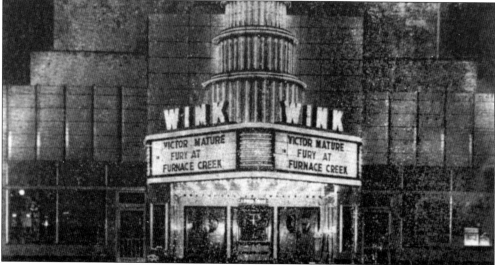

The Wink Theater opened in 1942, with J. C. Wink as manger of both it and the Crescent Theater. A tunnel built underground connected both theaters so Wink could move between them easily and ice could be transported to both. Admission was 33¢ for a main-floor seat and 10¢ for a balcony seat. The Wink was the first air-conditioned building in Dalton. (Courtesy of Sherry Cady.)

J. W. Looper Cotton Buyer, pictured around 1930, was an essential part of the cotton industry. Owned by John W. Looper and located at the corner of Morris and Hamilton Streets, the store handled most of the cotton coming to the Crown Cotton Mill. They bought, stored, and jobbed the cotton from local farmers. It was the headquarters for McCormick-Deering farm equipment. (Courtesy of Georgia Archives, Vanishing Georgia Collection, Image No. WTF043.)

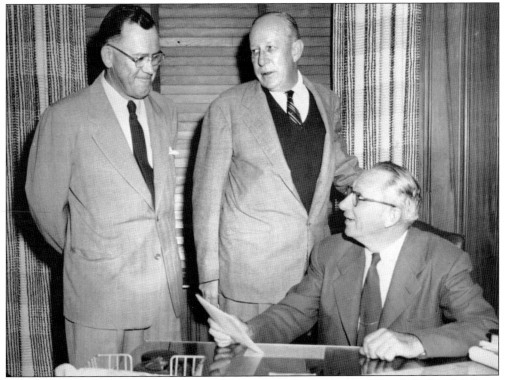

Cabin Craft was a pioneer firm in the factory production of tufted bedspreads. Robert McCamy (left), along with founding brothers Lamar (center) and Fred Westcott, developed a reputation for creating the highest-quality tufted bedspreads (with matching curtains). They made the bedspreads for Scarlett O'Hara's beds in *Gone with the Wind*. Cabin Craft was crucial to the evolution of tufting technology. (Courtesy of Georgia Archives, Vanishing Georgia Collection, Image No. WTF229.)

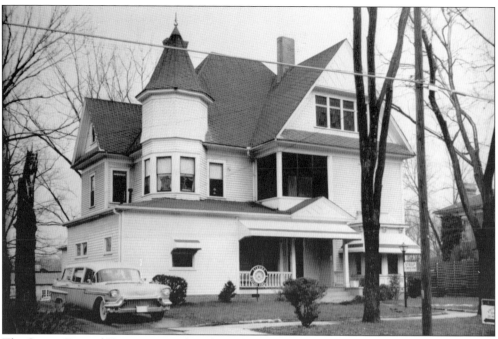

The Stroup Funeral Home, pictured in the early 1960s, was in business on Spencer Street from 1957 to 1969. Note the clock on the front porch. Other funeral homes in the community included the Love Funeral Home, the Kenemer Funeral Home, and the Willis Funeral Home. The Willis Funeral Home was the first African American funeral home in Dalton. (Courtesy of Georgia Archives, Vanishing Georgia Collection, Image No. WTF315.)

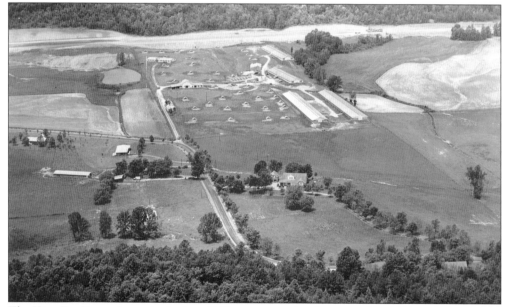

The King Egg Farm, shown in the late 1960s, was owned and managed by J. Edward King. It was located on Dug Gap Road. The King farm was known as the home where buffalo grazed. In the farm background are chicken coops and the construction of Interstate 75. (Courtesy of Betty King Posten and Mable McKone.)

Maret's Prescription Shop, shown in the 1960s, was located at 222 North Pentz Street. Owned by brothers Randall and Charles Maret, it served Dalton's downtown pharmaceutical needs for several decades. Both men played active roles in the community. (Courtesy of Randall and Charles Maret.)

In 1892, Catherine Evans saw a tufted bedspread from pre–Civil War days, and three years later, at the age of 15, she tufted a simple bedspread with square designs. She made another as a wedding present, and then orders began to arrive that would transform Dalton into the tufted-carpet capital of the world. (Courtesy of Tom Deaton.)

Soon there were so many orders for tufted items that Catherine Evans had to enlist friends and neighbors (such as Ethel Partin) to "tuft" spreads. Simple patterns used quilt frames and pots and pans to create designs. The tufts were made of eight threads pushed through the material and were bound in the fabric when washed and dried. (Courtesy of National Archives.)

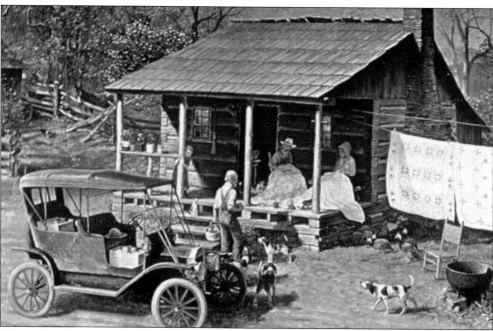

When the orders exceeded the ability of local ladies, who were tufting spreads in between their household chores, haulers began to fill their Ford Model Ts with spreads and yarn to enlist women throughout north Georgia, east Tennessee, and the Carolinas. John Clymer's classic painting depicts the hauler delivering the stamped sheeting and yarn. (Courtesy of Hamilton House.)

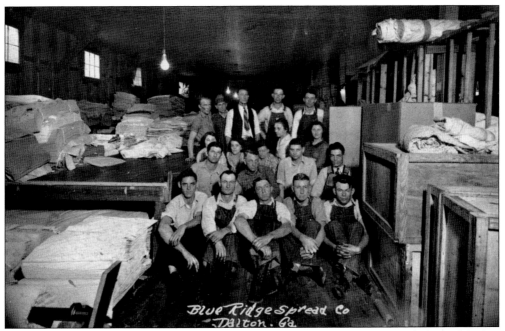

At the Blue Ridge Spread House, these men in the stamping room would stamp the spreads before they were sent out for tufting. A finished spread would be laid flat with the plain sheeting laid on top. Blocks of melted paraffin with bluing would be rubbed across it, and the tufts would make a mark where the chenille was to be stitched. (Courtesy of Georgia Archives.)

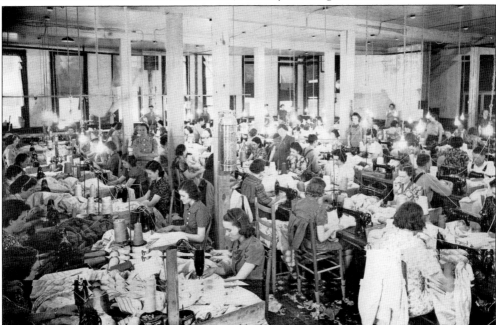

As the demand continued, mechanics adapted Singer 3115 sewing machines. The single needle would push the thread through the cloth, and a hook, or "looper," would catch the thread to keep it from being pulled out as the needle moved to the next stitch. This is a spread room at the J. & C. Bedspread Company. (Courtesy of Joe and Christine McCutchen.)

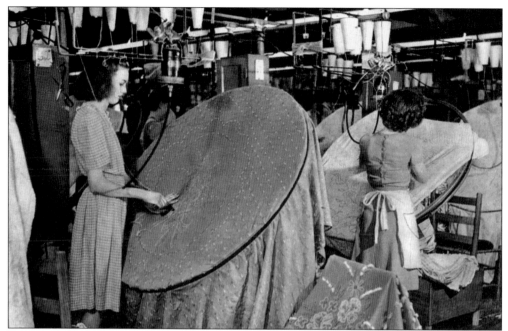

Bob McCamy, Lamar Westcott, and Peek Smith developed a needle-punch machine that used air to push the thread through the material that was stitched by Frances Massengill on a large hoop. Joe McCutchen, later the president of the Tufted Textile Manufacturing Association, developed this variation. (Courtesy of Jack Bandy.)

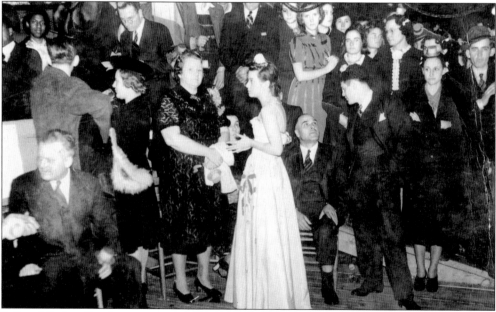

B. J. and Dicksie Bandy were owners of dry goods stores in Sugar Valley, but the depression in 1919 forced them to develop a bedspread business. Dicksie rode the train to the Northeast and sold enough spreads to get them started. They are believed to be the first millionaires in the business. They are seen in the center of a celebration with their daughter Christine and her husband, Joe McCutchen. (Courtesy of Joe and Christine McCutchen.)

The industry began to expand its product from bedspreads to "scuffes" bedroom slippers by the J. W. Bray Company, toilet tank covers, bath robes, and small throw rugs. This brought a demand for wider stitching, like this "goose neck" sewing machine, which had 24 needles fed from creels of thread above it. This machine was invented by Newt Kyle. (Courtesy of Prater's Mill Foundation.)

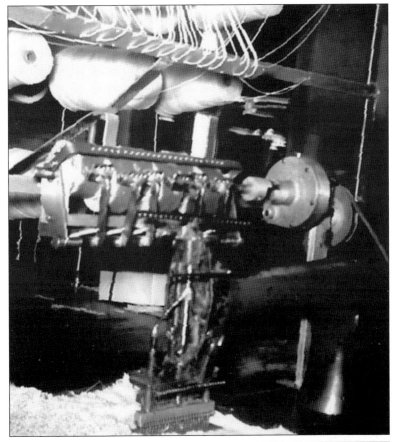

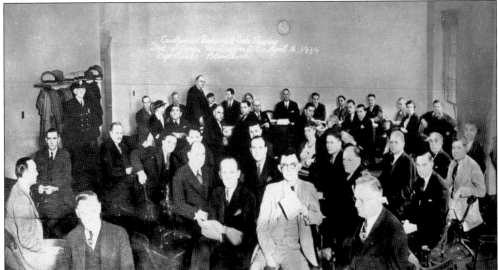

With the New Deal, new laws called for a minimum wage for workers in plants that was much higher than tufting workers were being paid (5 to 10¢ per hour). The Tufted Textile Manufacturers Association went to Washington, D.C., to plead their case at this Congressional hearing and were able to delay their implementation. (Courtesy of Joe and Christine McCutchen.)

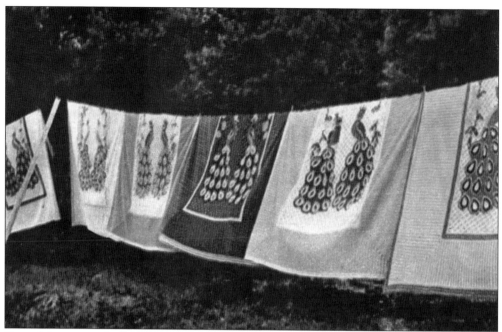

One of the most colorful designs developed for sale to customers was the peacock bedspread. It was said to have begun when women used the extra thread left over from tufting spreads to make these patterns. It was also said that they were only sold to Yankees because no Southerner would have one of these on their beds. (Courtesy of Randy Beckler.)

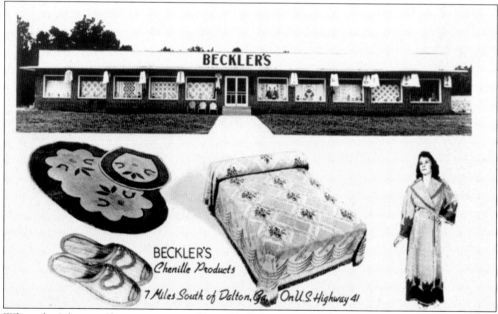

When the Johnson-Sherman route, or Dixie Highway, was paved in 1929, U.S. 41 became a major route between the North and Florida. Once the muddy, dusty road was replaced, spread lines sprung up between Cartersville and Chattanooga, Tennessee, and the stretch became known as "Peacock Alley." At one time, Burch and Claudell Beckler owned eight shops on the highway. (Courtesy of Randy Beckler.)

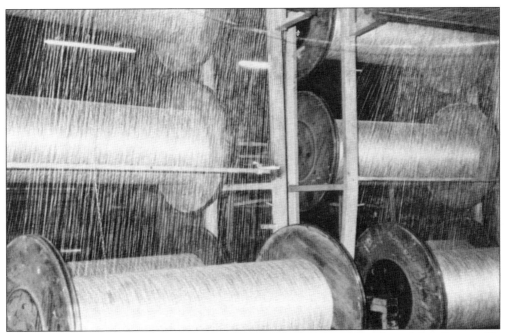

There were many inventors in the industry, but one of the most colorful was Mose Painter. He learned to fix things early and began as a tinker in the industry. He invented things such as the tenter frame, or carpet trimmers. The invention of beams came when he started his own company and was faced with a ceiling so low that he could not run creels. (Courtesy of Mose Painter.)

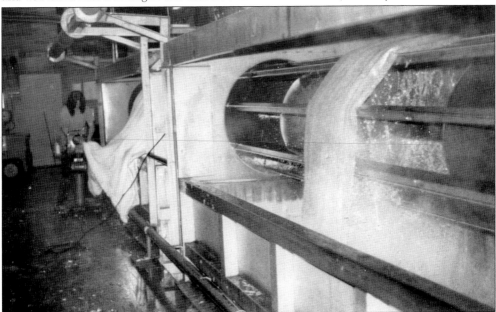

Once a spread, or later a piece of carpet, was tufted, it needed to be dyed. In the early days, it went to the Dalton Spread Laundry, where Clarence Shaw did the dying. Later the dying was done in this type of dye becks, which were large washing machines. At first, a paper bag with the dye was thrown in, and the carpet was dyed whatever color DuPont was supplying that week. (Courtesy of Vernon Foster.)

One of the most successful early carpet companies was Coronet Carpet, which was started in the old King Cotton building next to the railroad track. The floors were so weak that six workers had to carry the carpets to ship since a heister would break through the floor. Created by Jack Bandy, Bud Seretean, and Guy Henley, it was later bought by RCA for nearly $150 million. (Courtesy of Jack Bandy.)

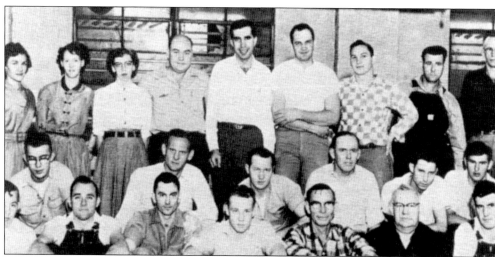

World Carpet was the creation of Piera and Shaheen Shaheen from $4,000 Piera had saved. Shaheen had an industrial engineering degree and was a wizard with machines. Piera had a business degree and worked precariously with the underground in fascist Italy. She used her business sense to run the economics for the company until they sold out and retired. (Courtesy of *World Carpet: The First Thirty Years*.)

Beaulieu Carpet is the creation of Carl and Mieke Bouckaert, seen here with Ed Ralston (left). In 1977, Roger De Clerck, a major producer of carpet in Europe, put his 22-year-old son-in-law in charge of his American venture of producing polypropylene rugs. Under Carl's leadership, it became a major force. (Courtesy of *Bedspreads to Broadloom: The Story of the Tufted Carpet Industry*.)

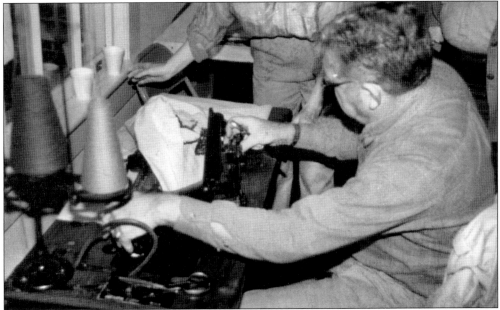

As the tufted carpet industry grew, there was a need for suppliers of yarns, backing, dyes, latex, machinery, computers, and sample books. Zach Norville is shown fixing a single needle machine at Crown Archives. He began by fixing his aunt's chenille machines but later realized the need for a local supplier of goods and services, and Norville Industries came into existence. (Photograph by Tom Deaton.)

Bob Shaw's father, Clarence, began as an expert at dying and created Star Dye and Finishing. While working as a salesman for wet-goods processing, Bob was called home to sell off the business. His older brother Bud had been in carpet manufacturing in Cartersville, and he was persuaded to use the business and the skills he had to, as Bob said, "create a world's class business." (Courtesy of *Bedspreads to Broadloom: The Story of the Tufted Carpet Industry*.)

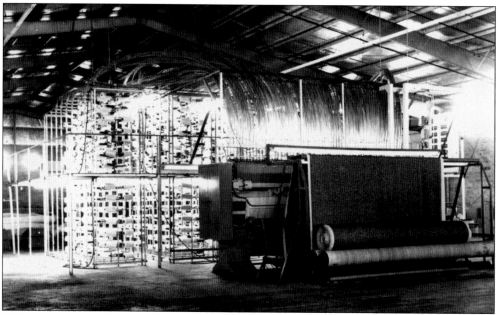

This is a modern tufting machine showing both the creels, which provided the synthetic yarns through tubes to the tuft machine. Currently, machines bring the raw, extruded material in one end of the plant, and finished carpet exits, dyed, backed, and ready for shipping at the other end. Dalton makes 85 percent of the tufted carpet in the United States. (Courtesy of Carpet and Rug Institute.)

Eight

SCHOOLS

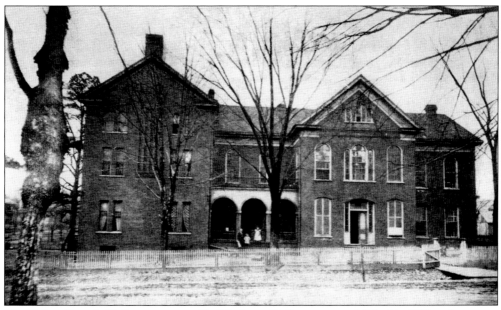

The Dalton Female College, sponsored by Wesleyan College, was established in 1872 at the corner of North Thornton Avenue and West Waugh Street. This was later the site of Dalton High School and the present-day City Park Elementary. Though called a college, it was a private school that girls attended until about age 16. (Courtesy of Dr. Ellen Thompson.)

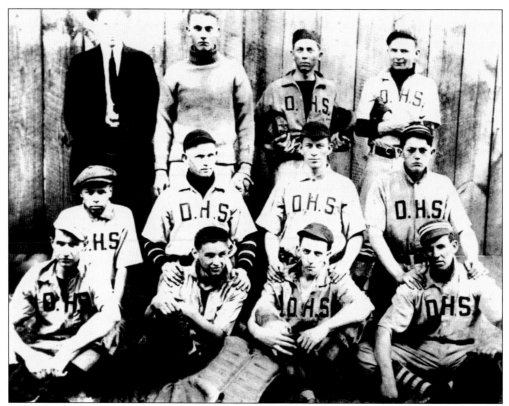

This is an early photograph of the Dalton High School baseball team, year unknown. In 1907, baseball was started at the school, which was a tuition school. (Courtesy of Jean Manly.)

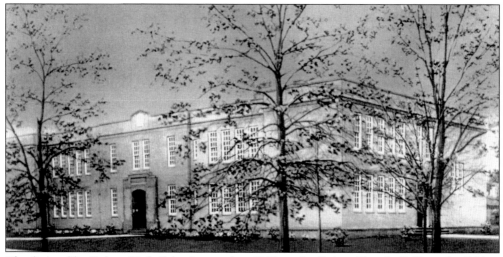

The first public Dalton High School started in 1909 in the Dalton Female College. In 1924, it was moved to the Thornton Building, located on Thornton Avenue. The first superintendent was Confederate general Bryan M. Thomas. The Thornton Building, pictured above, served as the Dalton High School until 1957, when the Crawford Building (Annex) was built and junior high students attended. Elementary students from the old City Park Elementary School attended some classes on campus. (Courtesy of Dalton Education Foundation.)

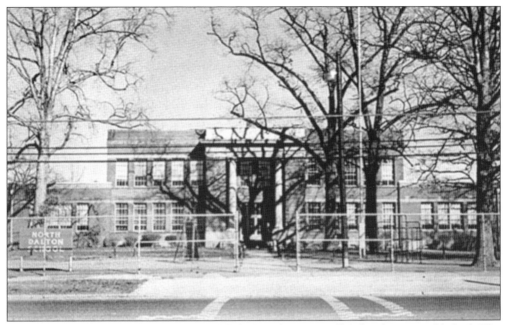

In 1913, the North Dalton School, modeled after the Fort Hill School, was established. The school had a playground, tennis court, and a softball area. Ice cream could be bought for 5¢ and a tomato-and-lettuce sandwich cost 21¢. The school closed at the end of the 1978–1979 school year and was later purchased by the city. (Courtesy of Sherry Cady.)

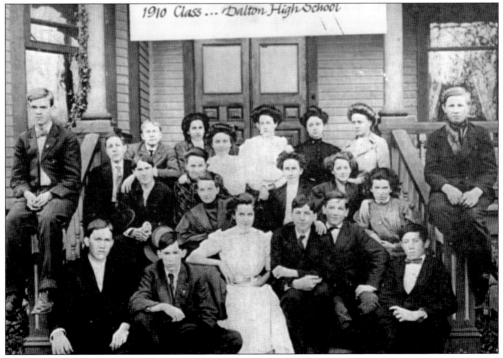

The 1910 Dalton High School class poses for a photograph. (Courtesy of Dalton Education Foundation.)

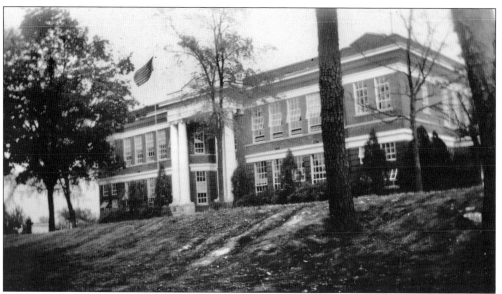

The Fort Hill School was build around 1915 and was located on Fort Hill. This photograph was taken in 1939. (Courtesy of Whitfield-Murray Historical Society.)

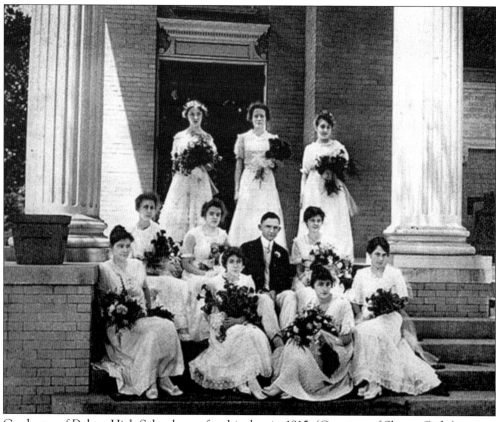

Graduates of Dalton High School pose for this shot in 1915. (Courtesy of Sherry Cady.)

Two young girls enjoy a cooking class at the Crown Point School. The school was for children whose parents worked at the Crown Cotton Mills. The school was an extremely small building. It went from being the Crown Point School to the Crown School to the Westwood School. The Westwood School still exists and is now called the Westwood Elementary School. (Courtesy of Dalton Education Foundation.)

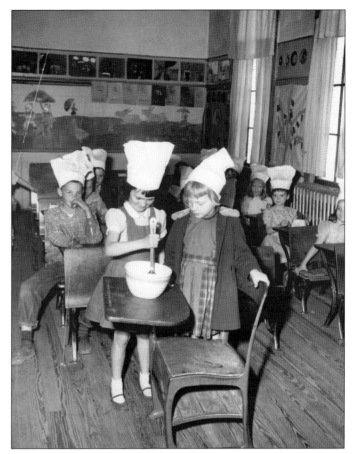

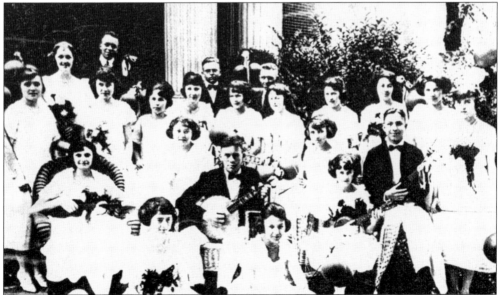

Smiling and enjoying memories of their senior year, the graduating class of 1921 celebrates the occasion with music. (Courtesy of *Bicentennial Book*.)

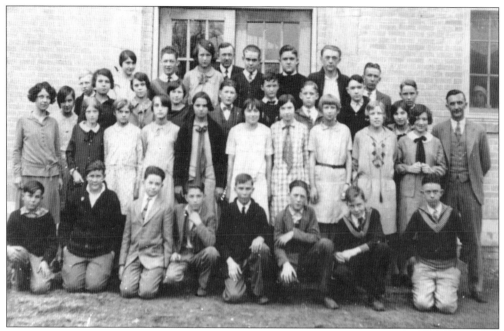

Teacher Mary Allman and class 8B of the Dalton High School pose for the class photograph. Pauline Hill Hackney is pictured in the second row, second from the left, and a Mr. Jones, the principal, is in the second row, far right. (Courtesy of Dr. Ellen Thompson.)

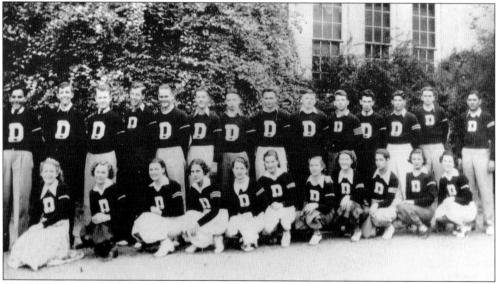

The 1936–1937 basketball teams proudly show off their "D" sweaters. Pictured from left to right are (first row) Lilliam Hamilton Hull, Wilma Whiteside Bandy, Ruby Lee Brooker Hackney, Clarice Hackney Bond, Dorothy Williamson Baker, Dicksie Bandy Tillman, Virginia Carson Austin, Sarah Twiggs, Martha Robertson, Marianne Wrench Stepp, and Martha Hurt Cook; (second row) Steve McCamy, Harold Nations, Arnold Stark, Bud Wallace, J. C. Metcalf, Ralph Howard, Sam Easley, Ewell Meredith, Arthur Lindsey, Vernon Hackney, Charles Caylor, Earl Hardin, T. J. Anderson, and coach John Shields. Bob Hart Jr. is not pictured. (Courtesy of Dr. Ellen Thompson.)

The Morris Street School was built in 1952, with 402 students in attendance during the first year of operation. The first principal was Emery Blunt Kirby, granddaughter of Dalton's first mayor, Ainsworth Emery Blunt. Today this building is home to the International Academy at Blue Ridge and the C³ Gifted Enrichment Center. (Courtesy of Dalton Education Foundation.)

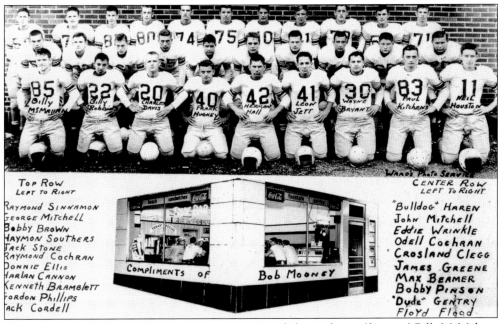

Pictured are the 1952–1953 Dalton Catamounts. From left to right are (first row) Billy McMahan, Billy Robbins, Charles Davis, Frank Hughey, Herman Hall, Leon Jett, Wayne Bryant, Paul Kitchens, and Neil Houston; (second row) "Bulldog" Haren, John Mitchell, Eddie Wrinkle, Odell Cochran, Crosland Clegg, James Greene, Max Beamer, Bobby Pinson, "Dude" Gentry, and Floyd Flood; (third row) Raymond Sinnamon, George Mitchell, Bobby Brown, Raymond Southers, Jack Stone, Raymond Cochran, Donnie Ellis, Harlan Cannon, Kenneth Bramlett, Gordon Phillips, and Tack Cordell. The coach was Alf Anderson. (Courtesy of Sherry Cady.)

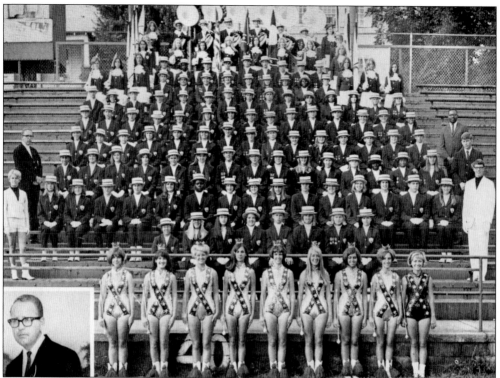

The first year of racial integration in Dalton Public Schools was 1968–1969. At left is director Darry Pilkington. On the right are Melvin Russell, former director of the Emery Street School band, and "newcomer" Mickey Fisher, who served the band for 33 years. Under the direction of Darry Pilkington, they were the three-time winners of the "Greatest Band in Dixie" championships in New Orleans, Louisiana. (Courtesy of Mickey Fisher.)

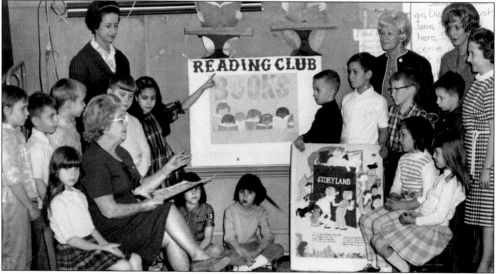

Students are focused and engaged in learning about the Reading Club at one of the Dalton Public Elementary Schools. This is Mable Ingram's class, with Barrett Whittemore pictured at the far left. (Courtesy of Dr. Ellen Thompson.)

In July 1963, the Dalton Junior College was chartered to serve the developing educational demands of northwest Georgia by offering associate, certificate, and technical degrees. This was the master layout of the campus. In May 1965, the county voters, by a 26 to 1 margin, approved a bond issue of $1.8 million to begin construction. (Courtesy of Dalton State College Public Relations.)

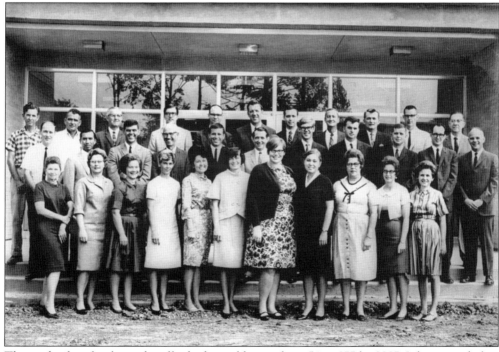

This is the first faculty and staff, which would grow from 54 to 275 by 2007. It began with four buildings and expanded to 10. It initially had 10 programs of study, but by 2007, there were 4,400 students in more than 100 programs offering certificate, associate, and bachelor degrees in seven schools of study. (Courtesy of Dalton State College Public Relations.)

The first president, Dr. Arthur M. Gignilliat, welcomed the first group of 524 students in 1967. In 1970, Dr. Derrell C. Roberts became president, and the college experienced a large growth in the student population. In 1994, Dr. James A. Burran became president, and the college became a four-year institution with major capital improvements and an active foundation. In 2008, Dr. John Schwenn became the school's fourth president. (Courtesy of Dalton State College Public Relations.)

The teaching of biology and anatomy was important for the students in the general education curriculum, as well as the nursing students. Prof. Mel Ottinger (right) explains the bones of the hand to, from left to right, Libby Scott, Jan Koker, and Clyde Thompson. Math and natural sciences were also taught in the building with equipped labs. (Courtesy of Dalton State College Public Relations.)

This tricycle race was part of the Spring Festival, which meant that spring fever had arrived on campus. From left to right, James Heard, Jerry Bay, and Randy Beckler race across the parking lot, while Mike Green gives directions and heckles them. The faculty dunking booth was always a favorite at the festival. (Courtesy of Randy Beckler.)

The student government was responsible for coordinating the clubs and activities. These members are collecting Christmas toys for the needy. Members are, from left to right, Paula Wikins, Jane Hutton, Glenda Caldwell, Deanne Crider, Lew Higgins, Annette Grigsby, and Bill Holden. (Courtesy of Dalton State College, Mollie Rogers.)

The Roadrunner basketball team was always key to the life of the college. The college gym, called "Death Valley," would be filled long before a game started. In this 1969 game, Earl Thompson grabs a rebound away from a Georgia Military College player, while Gary Smith plans his next move. (Courtesy of Dalton State College, Mollie Rogers.)

In 1972, the Roadrunners represented the Southeastern Region XVII at the National Junior College Championship tournament in Kansas and finished 35-2. They were ranked second in the nation and were led by coach Melvin Ottinger and coach Dick Coleman. In their 10 years in existence, they won more than 240 games and twice went to the national tournament. (Courtesy of Dalton State College, Mollie Rogers.)

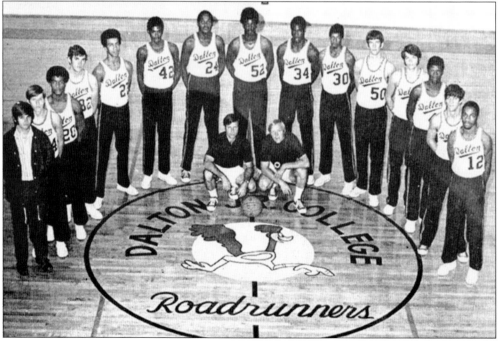

The Dalton Junior College golf team in 1968 competed successfully in state and area tournaments. The members are, from left to right, Bill Roberts, James Womack, Geri Geren, Mike Head, coach Mike Moorhead, and Kyle Smith. (Courtesy of Dalton State College, Mollie Rogers.)

The Dalton Junior College cheerleaders are, from left to right, Macca Frost, Sally Strain, Janet Williams, Susan Mossman, April King (captain), and Shelia Miller. There were annual team tryouts, and large numbers of girls who had been cheerleaders in area high schools competed for the honor. (Courtesy of Dalton State College, Mollie Rogers.)

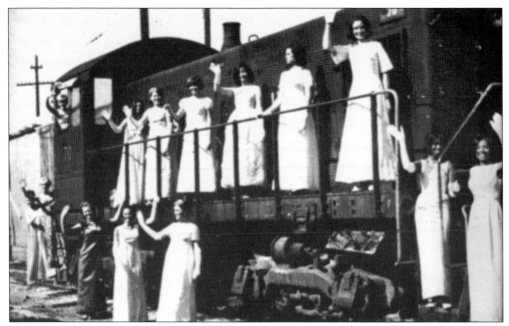

These beauties are competing for the title Miss Chaparral and for the opportunity to be featured in the college yearbook, the *Chaparral*. In 1969, the honor went to Libby Scott, and the two runners-up were Sharon Talley and Judy Ridley. (Courtesy of Dalton State College, Mollie Rogers.)

Academics brought excellent students to the college, and the college had one of the best two-year-college academic quiz teams in the South. The college trophy cases are filled with trophies won in competitions throughout the Southeast. This is the 1998 team, which won three championships. (Courtesy of Dalton State College, Mollie Rogers.)

Nine

GOVERNMENT

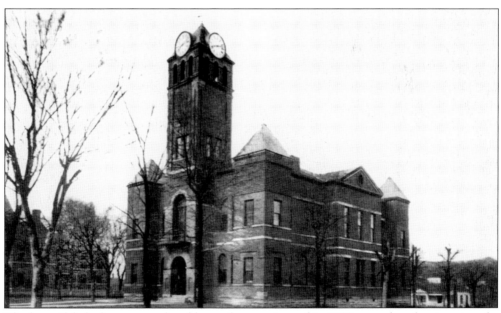

The beautiful clock tower on the old courthouse, pictured in 1892, served as the timepiece for the town of Dalton. It became known as "the Clock." The old courthouse was also used as a county jail. The courthouse was renovated several times but was torn down in 1960. (Courtesy of Sherry Cady.)

Pictured is the old 1901 Seagraves Dalton Fire Department ladder wagon being driven by Purnie Baxter with the help of two horses, Joe and Dan. It is believed that the horses were trained so well that when the alarm sounded they ran to the fire wagon to be harnessed. (Courtesy of *Bicentennial Book*.)

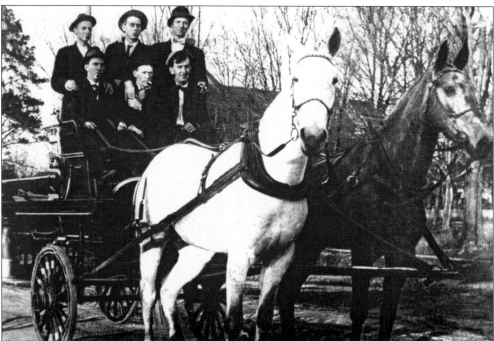

During Dalton's early days, two horses pulled the fire wagon. Early firemen, from left to right, are (seated) Chief Hardy Springfield, holding the reins, Oliver Dickson, and Baxter Maddox; (standing) Guy Richardson, Dan Moore, and Howard Searle. (Courtesy of Arnold King.)

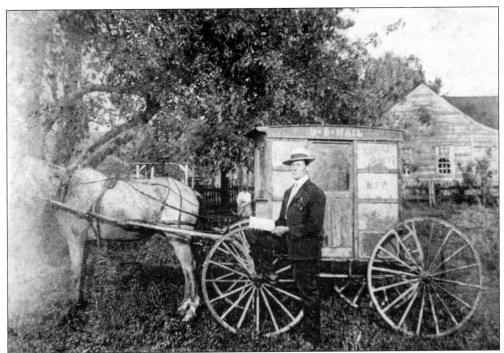

This photograph depicts how mail was delivered in the early 1900s in Dalton. (Courtesy of Sherry Cady.)

Standing proudly by the mail buggy, this unidentified man poses for a photograph. This image was taken in Cohutta in 1905, and the man is distinguished as the first mailman for that area. (Courtesy of *Bicentennial Book*.)

A replica of Independence Hall in Philadelphia, Dalton's first permanent post office was established in 1910. Located in the heart of downtown, at the corner of Hamilton and Crawford Streets, it remained the post office until a new structure was built in December 1965. The old post office now houses the City Board of Education's Administrative and Services Building. (Courtesy of Georgia Archives, Vanishing Georgia Collection, Imagine No. WTF247.)

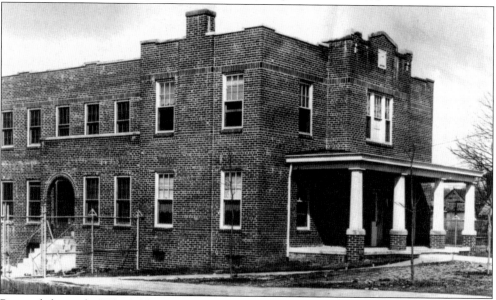

Pictured above, the Whitfield County and Dalton jail looked sturdy enough to hold the criminals of the early 1920s. The jail was located on South Hamilton Street and was torn down around 1976. (Courtesy of Georgia Archives, Vanishing Georgia Collection, Imagine No. WTF301.)

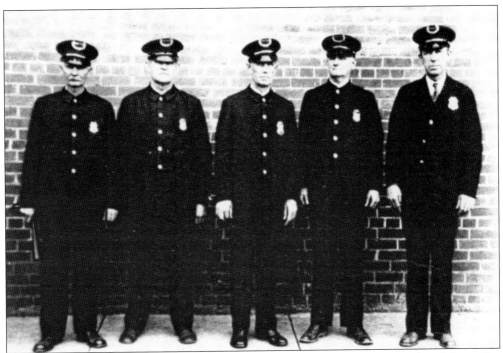

Members of Dalton's police department in the late 1920s included these five men, from left to right: Hill Anderson, Henry Hill, unidentified, Clifford Warmack, and Tom Peeples. Peeples was later the sheriff of Whitfield County. Notice the small wooden batons. (Courtesy of *Bicentennial Book*.)

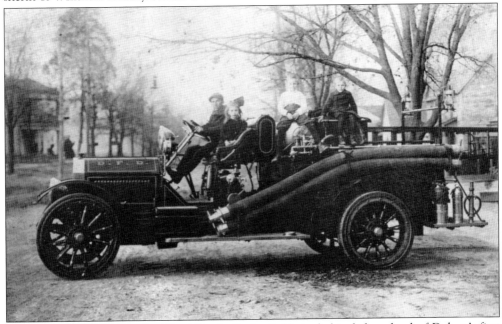

In this *c.* 1923 photograph, Chief Hardy Springfield sits behind the wheel of Dalton's first motorized fire engine, a 1918 LaFrance. With him are his children, Lucille (seated beside him), with Bud and Bill in the back. (Courtesy of Georgia Archives, Vanishing Georgia Collection, Image No. WTF125.)

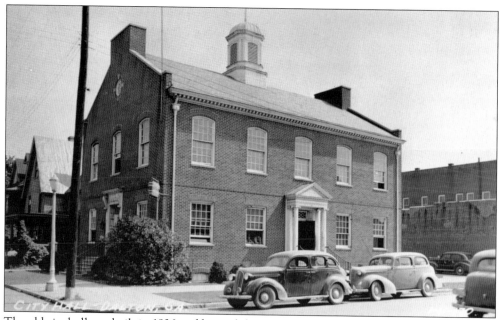

The old city hall was built in 1936 and housed the city government offices, the city clerk's office, the municipal court, and the police department. On the second floor was the large courtroom and several offices. It was designated as a fallout shelter during the cold war. The old city hall was thought to have held city prisoners in the basement. (Courtesy of Georgia Archives, Vanishing Georgia Collection, Image No. WTF099.)

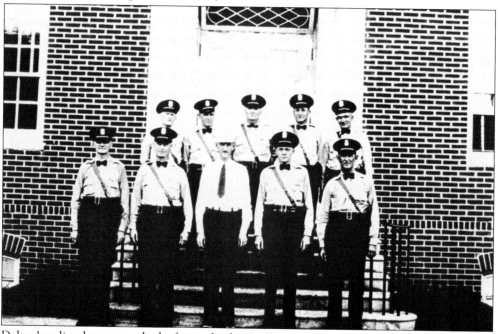

Dalton's police department had a force of only 10 officers in 1939. They were, from left to right, (first row) Bill Britton, a Mr. Johnson, Chief Burgan Butler, Cecil Koewn, and Burt Morrison; (second row) Bill Southern (later a chief), Spence Goad, Dan Callaway, John Roe, and Chigger Joyce. (Courtesy of Arnold King.)

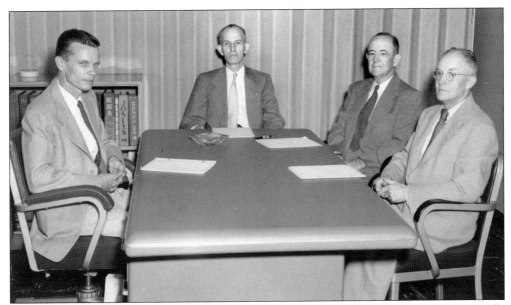

Dalton Utilities began in 1887, when Dalton Water Works was built at the Crown Cotton Mills spring. By 1898, electricity was available. Former Dalton Utilities president and chief executive officer V. D. Parrott Jr. (left) is pictured around 1952, along with the Board of Water, Light, and Sinking fund commissioners, from left to right, Howard L. Trammell, Frank R. Jolly, and Howard P. Manly. Parrott was superintendent and president of Dalton Utilities from 1945 to 1982. (Courtesy of Dalton Utilities.)

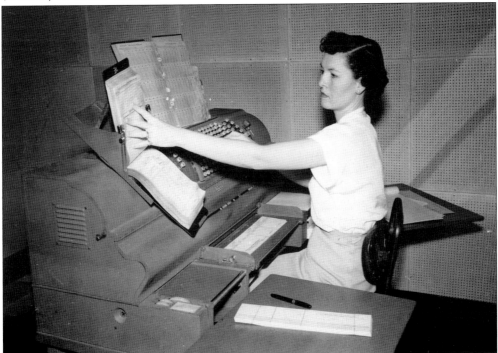

Dalton Utilities employee Nan Walters Bartenfeld creates utility bills on an automated billing machine in the 1950s. (Courtesy of Dalton Utilities.)

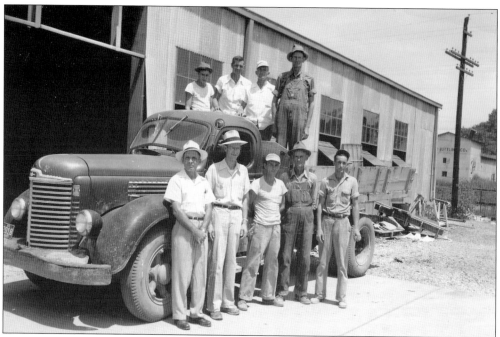

Pictured are D. F. "Jack" Burnham (front left) and crew in the 1940s or early 1950s. Burnham began his career at Dalton Utilities in 1943 and was instrumental in developing and upgrading Dalton's gas, sewer, and water systems. Although he retired from the utility in 1975, he worked as a consultant on the development of the land application wastewater treatment system in the 1980s. He passed away on October 26, 2004, at the age of 94. (Courtesy of Dalton Utilities.)

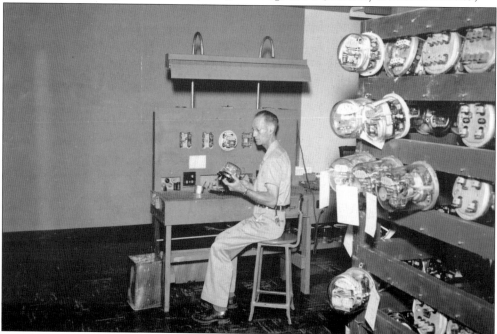

Dalton Utilities employee A. B. Murphy repairs meters in Dalton Utilities' meter shop during the 1950s. (Courtesy of Dalton Utilities.)

Ten

HISPANICS IN DALTON

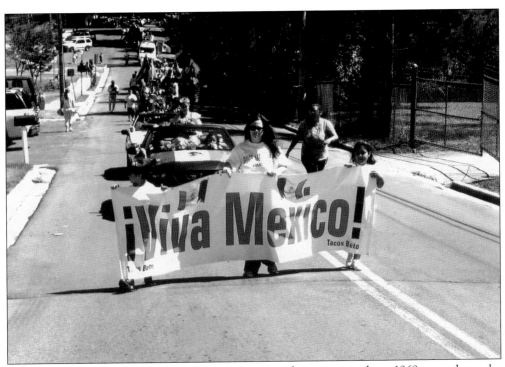

Viva Mexico! The first group of Hispanics came to the area as early as 1969 to work on the construction of Carter's Dam, a U.S. Army Corps of Engineers project located about 40 miles southeast of the city. Upon completion of the large earthen dam, the remaining Latino men migrated to other construction jobs or to other labor positions formally filled by North Georgia natives. (Courtesy of Maria Sosa.)

Maria Sosa was the first Hispanic to come and stay in Dalton. In 1969, two busloads of Mexicans came from El Paso, Texas, to Dalton seeking work. Although there were about 30 in each bus, all but Maria soon went back. She stayed alone and worked at ConAgra, the local chicken processing plant, even though the pay was low and the work degrading. (Courtesy of Maria Sosa.)

In 1979, Manuel and Rita Salazar came to Dalton as one of the first Hispanic families in the community. Homer Garcia brought them to Dalton. They went to work for Coronet Carpet and stayed there until they retired. They had four children, and pictured is their extended family today. About 54 different individuals stayed with them during those years. (Courtesy of Manuel and Rita Salazar.)

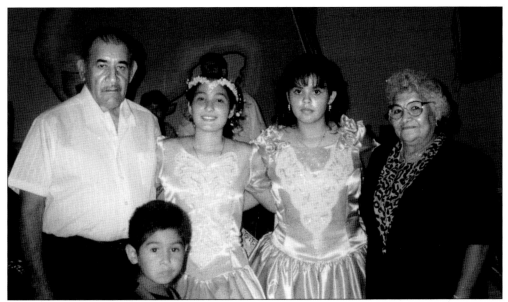

The *quinceanera* celebration commemorates the 15th birthday of young Latino women, and in the past, the event symbolized that the young woman was ready to date and received the permission and blessing of her parents and family to do so. Manuel (left) and Rita Salazar (right), with Esmeralda Soto (second from left) and Angelina Hurtado (third from left), enjoy this large social event with a host of family and friends. (Courtesy of Manuel and Rita Salazar.)

Although born in San Francisco, California, Francisco Palacios got his education in marketing in a Catholic college in Guadalajara. Work opportunities drew him to Dalton, although he only spoke Spanish. After various jobs, he began to help develop the local paper's Spanish supplement. He now owns and manages *La Voz* as well as two grocery stores, *La Providencia*, and is active in *Alianza*. (Courtesy of Tom Deaton.)

The annual Mexican Independence Day parade on September 15 or 16 is presided over by the queen (*reyna*) of the parade as well as queens who represent the community, Guatemala, and El Salvador, as well as a princess and *condessa*. They are dressed in their native Latino dresses, and it is an honor to be chosen to represent their community. (Courtesy of Maria Sosa.)

Francisco Cruze is a direct descendant of the Aztecs, and with his daughter, he annually represents the ancient Aztec heritage in the parade. The varieties of Central and South American cultures that fill the Latino community of Dalton celebrate the colorful traditions that they bring to the community. Awards are given in the parade for the best decorated floats, cars, beautiful dresses, and participants. (Courtesy of Maria Sosa.)

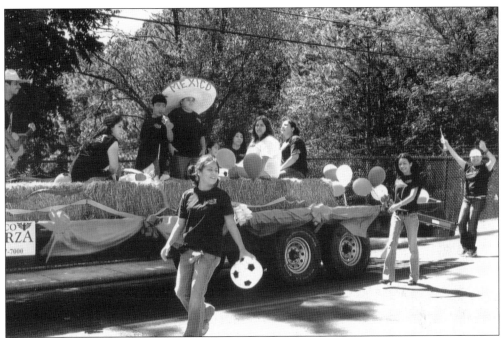

There are numerous floats in the parade, and they are sponsored by both Hispanic and Anglo businesses. This float, sponsored by Alliance Bank, which also has Spanish-speaking personnel in its bank branches, symbolizes the amount of money that the Latino community contributes to the city's economy. There are Hispanic real estate firms, newspapers, salons, groceries, tax services, car lots, cafés, clubs, and numerous service businesses. (Courtesy of Maria Sosa.)

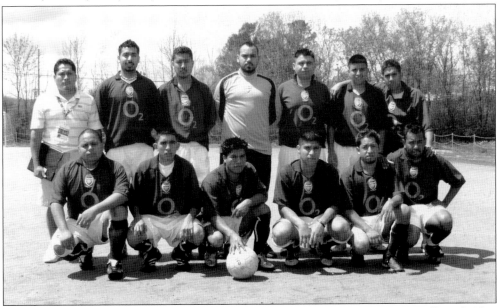

There are more than 70 soccer teams in Dalton. There are four men's divisions, usually with 16 to 18 teams each, and one women's division with 8 teams. On the opening day of the season, there is an elaborate ceremony, with each team represented by a queen who precedes the team in the parade. There is food and music, and as many as 3,000 turn out. (Courtesy of Maria Zamora.)

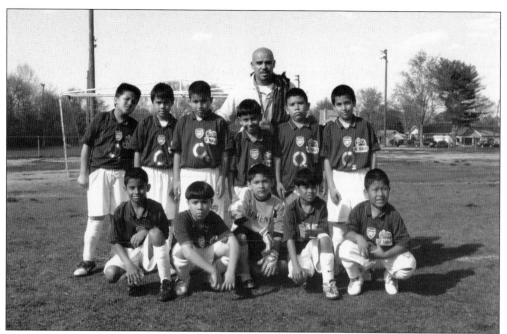

The children's league, which is part of the League of St. Joseph, has so many teams that there are seven divisions, and everyone turns out to watch their children play. Eloy Ortiz is the coach of the San Pablitos team. Soccer matches are truly a family affair, with all the families of a team sharing in the competition and festivities. (Courtesy of *La Voz*.)

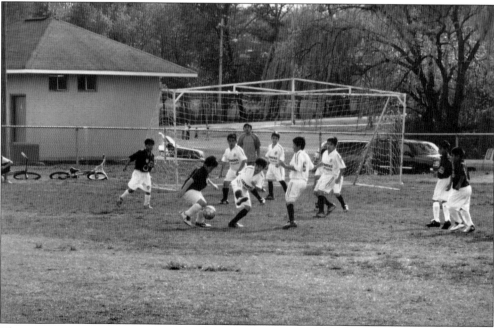

The youngsters are just as competitive, and they have their own uniforms and play just as hard. The San Pablitos team is trying to score against the La Paz team. One of the problems faced by the community with this many leagues is finding a place for all the games during the week. This game is being played behind Brookwood Elementary. (Courtesy of *La Voz*.)

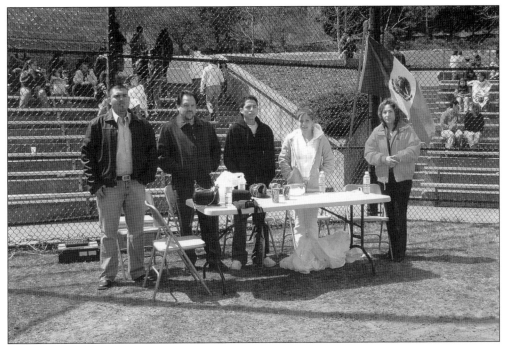

The beginning of baseball season is also an important event, and, from left to right, Eduardo Loa, Julio Salazar, Julio Salazar Jr., Rocio de Santiago, and Maria Resario Calderon are judging the team's queens, uniforms, and banners at the beginning of the season. (Courtesy of *La Voz*.)

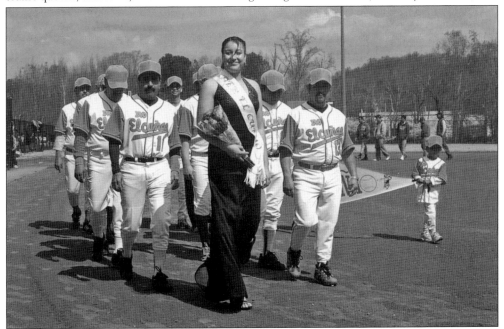

Each team chooses a queen who leads them in the opening ceremony, while the mascots carry the banner of the team. Maria del Rosario Perez is the godmother of the Deportivo Tacos El Cunao, and their manager is Adalberto Brito. This is one of the oldest continuous teams in the league, and they are usually a chief competitor. (Courtesy of *La Voz*.)

The *Alianza Communitaria Latino Americana, or* Latin American Community Alliance, provides economic and logistic support for individuals wanting to start their own small business or to simply learn the American economic system. From left to right, attorney Erwin Mitchell, founder of the Georgia Project, is joined on stage by Angel Silva and America Gruner as they emphasize the benefits and accomplishments of the past year. (Courtesy of *La Voz*.)

An Atlanta Mexican mariachi band serenades this annual meeting of the *Alianza Communitaria.* One of the major objectives of the organization is to "research and tailor programs that will benefit the Latino community in all finance issues." The alliance works with the local chamber of commerce to blend both business communities together. Norberto Reyes is the president in 2008. (Courtesy of *La Voz*.)

ACKNOWLEDGMENTS

This book is dedicated to the citizens of Dalton and Whitfield County who contributed their time and talents in providing photographs and historical data for the book. Of the 400 pictures submitted, we could use only 240 pictures. Please know that you still contributed to the creation of archives of Dalton's history, and we appreciate your help. We also dedicate this book to the 220 children of the C³ Center at the International Academy of Blue Ridge, who searched for pictures, researched Dalton's history, and wrote captions.

We want to thank the Dalton State College, the C³ Center, and Priscilla George, coordinator of the Dalton Public Schools Gifted Program, for allowing the authors to devote so much time and energy to this project. We particularly want to show our appreciation to Dudd Dempsey and Mollie Rogers of Dalton State College and to Hannah Ashmore and Lisa Cushman of the C³ Center, whose scanning, organization, and support made the book possible. We also want to thank the Dalton Public Schools Technology Department, Deborah O'Hearon, Michael Miller, and David Bynum for their time and help with the tremendous technology assistance needed to complete the book.

For historical accuracy, we must thank Mark Pace, Joanne Lewis, Jean Manly, "Tut" McFarland, Dr. Ellen Thompson, Marcelle White, Jean Lowery, Curtis Rivers, Judy Alderman, and Courtney, Rick, and Evelyn Myers. Don Davis provided his pictures and experience from publishing with Arcadia Publishing to keep us on track.

Again, let us thank all those whose names appear with the pictures and thus give the book its character. With only four months to complete the book, we deeply appreciate all those whose hard work and dedication made the book a reality.

We hope that you enjoy the history of Dalton. We have tried to bring to light pictures that have not appeared in print before. Our mission when writing the book was to help give a more complete picture of our city's interesting and exciting past. This book is finally dedicated to you, the reader. May you see friends and relatives as you gain knowledge about this great town of Dalton.

ACROSS AMERICA, PEOPLE ARE DISCOVERING SOMETHING WONDERFUL. *THEIR HERITAGE.*

Arcadia Publishing is the leading local history publisher in the United States. With more than 4,000 titles in print and hundreds of new titles released every year, Arcadia has extensive specialized experience chronicling the history of communities and celebrating America's hidden stories, bringing to life the people, places, and events from the past. To discover the history of other communities across the nation, please visit:

www.arcadiapublishing.com

Customized search tools allow you to find regional history books about the town where you grew up, the cities where your friends and family live, the town where your parents met, or even that retirement spot you've been dreaming about.